IMAGES
of America

POULSBO

IMAGES
of America

POULSBO

Judy Driscoll and Sherry White

ARCADIA
PUBLISHING

Published by Arcadia Publishing
Charleston, South Carolina

Printed in the United States of America

Library of Congress Control Number: 2013943425

For all general information, please contact Arcadia Publishing:
Telephone 843-853-2070
Fax 843-853-0044
E-mail sales@arcadiapublishing.com
For customer service and orders:
Toll-Free 1-888-313-2665

Visit us on the Internet at www.arcadiapublishing.com

CONTENTS

ACKNOWLEDGMENTS

The Poulsbo Historical Society has a growing collection of images from the North Kitsap area due to interested community members who have generously shared their private collections and allowed us to use those images in our publications. *Poulsbo* represents images from that collection. The authors have drawn on this collection of early images to represent this multifaceted community. An effort has been made to include images new to the collection as well as some of the tried-and-true photographs that have become iconic in representing the history of the community.

The following Poulsbo Historical Society members have enthusiastically given their time, knowledge, and expertise in preparing this volume: Gerri Johnson, Dennis Johnson, Sherol White, Hildur Gleason, Mickey Albanese, Patsy Armstrong, Roseanne Mitchell, Jan Lofall, Bernice Denton, Camille Meyers, Ruth Peterson Reese, and Judy Driscoll.

Except for those carrying a specific credit line, all photographs in this volume are from the collection of the Poulsbo Historical Society.

INTRODUCTION

Set on the shores surrounding Liberty Bay, Poulsbo is more than a town. It is a collection of small communities on the north Kitsap Peninsula settled in the late 1800s by Scandinavian immigrants looking for a setting that reminded them of the fjords of Norway, Sweden, Finland, and Denmark. Here they farmed, fished, and logged together, retaining their cultures while working together to build a community where their descendants could be proud of their ancestry and revere the homeland but in all respects meld as Americans. The immigrant communities, many of which had their own post office in the early days, retain their area names—Big Valley (Gudbrandsdalen), Little Valley, Breidablik, Finn Hill, Lemolo, Lincoln, Lofall, Pearson, Scandia, Vinland, and Virginia Point—but collectively for post office zip codes and for the purposes of this volume, they are Poulsbo.

The earliest name bestowed on the land surrounding the bay was Tcu Tcu Lac, "the place of maples." Tcu Tcu Lac provided the indigenous Suquamish tribe inhabiting Agate Passage with a convenient larder. Spawning salmon and schools of cod and smelt, succulent shellfish, and a plethora of the versatile dogfish (sand sharks), as well as ducks, geese, and wild game, made Tcu Tcu Lac a treasure worth keeping. Perhaps it is a blessing that Capt. George Vancouver did not see the entrance to the bay during his voyage of 1790, although he did see the tribal longhouse.

When George Wilkes surveyed in 1841, his party did find Agate Passage and named it. But it is unclear whether he actually sailed into the bay. From his maps of the area, the bay appears round rather than funnel shaped, so it is doubtful that he actually sailed into it, perhaps being satisfied with a quick look from the entrance.

George Meigs established a mill at Port Madison on Bainbridge Island in the 1860s. It did not take long for an enterprising mill employee, Harry Prescott, to realize he could file claims on the small irregularly shaped sections of land around the bay and make a profit not only from the trees but also from the fish traps he built for harvesting dogfish and rendering them into the oil in demand at the mill. Many early settlers bought land from Prescott's holdings.

Ole Stubb, credited as being the first permanent Norwegian settler in Kitsap County, settled at the entrance to the bay about 1874. In August 1883, his niece's husband, Jorgen Eliason, visited and, at Ole's urging, filed on a homestead near a log dump up the bay, today's Poulsbo. Peter Olson accompanied Eliason and filed on a neighboring homestead. Olson quickly resold his property to Torger Jensen, but Eliason stayed, securing his distinction as the father of Poulsbo.

Three months later, the second settler, Iver B. Moe, moved to the bay. In 1886, tired of rowing his boat to Seattle for supplies and mail, Iver Moe applied for a post office and requested Paulsbo as the official name. The postmaster general misread his handwriting and granted the request but misspelled the name as Poulsbo. The town's unique name has been a source of much speculation. Some hold that Poulsbo, meaning "Paul's place" in Norwegian, was named for former logger Paul Wahl, who had a log dump in the area during the 1870s and 1880s, but others vehemently contend that Moe named it for his farmland in Norway. Perhaps Moe had enough of a sense of humor to

figure that the name was appropriate for both reasons. More likely he was trying to keep up with Eliason, who had donated the land for the church in 1886. The church was named Fordefjord for Eliason's homeland in Norway, and since the Moes were highly competitive, Iver may have been slightly motivated by one-upmanship.

A post office does not ensure a town. It was not until 1908 that 400 residents of Poulsbo petitioned the county to become an incorporated town. At that time, only lands on the east side of the bay were included in the city limits. When State Highway 21 connected Bremerton to Port Gamble in 1933, the west side of the bay developed into a business strip consisting of building suppliers, grocery stores, and gas stations known informally as Poulsbo Junction or simply "the Junction." The Junction resisted annexation to the city until 1974.

Surrounding the town, within a five- to six-mile walk through the woods, were the many communities that today make up the area known as Poulsbo. With trails or water as their only connections to the outside world, these hardy settlers relied on each other for their labor needs in farming and for social activities. Small churches existed in them, as well as one- or two-room schoolhouses. But with the completion of the graveled Highway 21 in the 1930s and the proliferation of automobiles, these communities became more identified with the Poulsbo business district and school system.

Two other events served to define Poulsbo as the center of the North Kitsap area: World War II and the building of the Bangor Trident Submarine Base at Bangor in 1974. The Keyport Naval Base had existed at the entrance to the bay since 1914. With the entrance of the United States into World War II, many more civilian workers were needed at the base. Poulsbo was chosen as the site for government housing for the hundreds of workers flooding the base. Seemingly overnight, Poulsbo grew by 360 new housing units. Nearly every home in town rented out one or two bedrooms to civilian workers. Poulsbo's population nearly doubled in a two-year period. For the first time, the community could no longer claim to be purely Scandinavian. Old-timers hoped that at the war's end the newcomers would leave for greener pastures, but it was not to be. There was a small drop in population following the war, but the Cold War ensured employment at Keyport as well as in the Bremerton Naval Shipyards. Newcomers remained and took active roles in the community. Through the 1950s and 1960s, Poulsbo's population stabilized around 1,200 to 1,400, but in 1974, the opening of the submarine base a scant seven miles from town brought a population explosion to Poulsbo that changed it forever. Today, once isolated communities surrounding the bay are populated with housing subdivisions and business parks. Poulsbo's city limits, now reaching one to two miles from the bay, may not have brought these communities into the city, but it is certainly in the realm of possibility that one day they may be officially Poulsbo.

Curiously, Poulsbo has maintained its unique Scandinavian ethnicity. Rather than the newcomers changing the town, the town has adopted them into the fold, and some of those adoptees fiercely defend Poulsbo's right to "be Norwegian." An old saying in town is that there are two kinds of people, those who are Norwegian and those who want to be. It's a Poulsbo state of mind.

One

WATER

OUR LIFEBLOOD

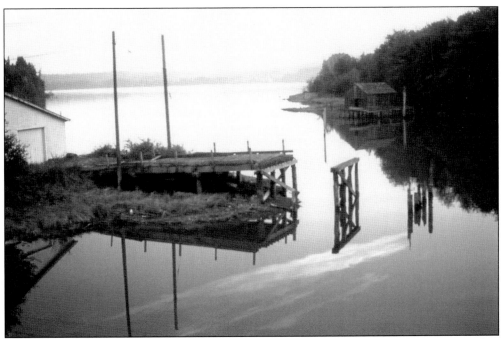

Liberty Bay, first called Dogfish Bay, has been vital to the development of Poulsbo. Used to move logs to market as well as rafts loaded with cook shacks, bunk houses, and crews along the shoreline as they logged the virgin forest, the bay has been a haven for commercial and sports fishermen. For the first 20 years, water was the only way to transport goods and people in and out of Poulsbo.

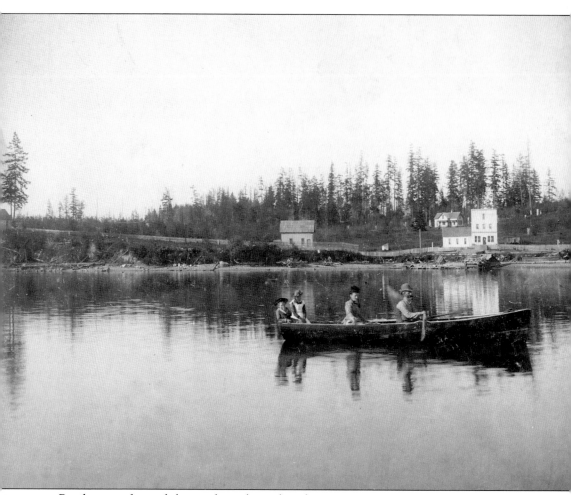

Rowboats, rafts, and sloops, the only modes of transportation on Dogfish Bay, could be fun, but the 28-mile trip to Seattle for supplies and mail was grueling. Sudden squalls could make the going rough! When Iver Moe was named the postmaster in 1886, the mail was delivered by steamer and received at his home a mile from town. Seven months later, the post office was transferred to Hostmark's general store in Poulsbo, where it remained until 1908. Adolph Hostmark became the second postmaster. After his death in 1895, his wife Tina became postmistress. Shown from left to right around 1890 are Anna, Signe, Tina, and Adolph Hostmark. The white Hostmark store sits on the shore with Martin Bjermeland's home on the hill. Both buildings still stand in Poulsbo.

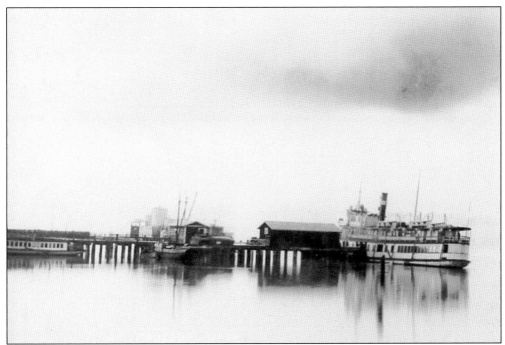

There were many docks around Dogfish Bay. The early docks, built without creosoted pilings, had a life span of about 10 years. Ownership of a wharf or leasing a spot on the dock could make or break a steamboat company. Because the town's docks had no central manager, a dock would often be absorbed by one of the steamboat companies. Shown here is the Eliason dock.

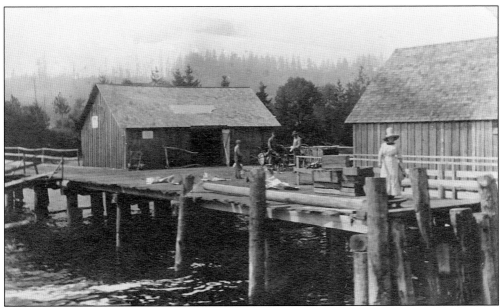

Passengers waited at the end of docks like this one at Scandia allowing access to the steamboat without traveling to Poulsbo. A boat would never leave a regular stop early but might run late if there was a large amount of freight to be offloaded or a large crowd of passengers. Poulsbo was a scheduled stop. On a good day, travel from Poulsbo to Seattle could take two hours.

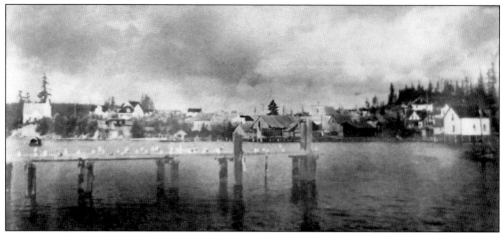

Steamers leaving Poulsbo stopped at Scandia, Pearson Point, Lemolo, Virginia Point, and Keyport. Small unnamed docks might flag the steamer down. If the tide was low, a hopeful passenger might signal the steamer from a rowboat. The renaming of Dogfish Bay to Liberty Bay may have come from a minor stop in Lemolo named Liberty Place.

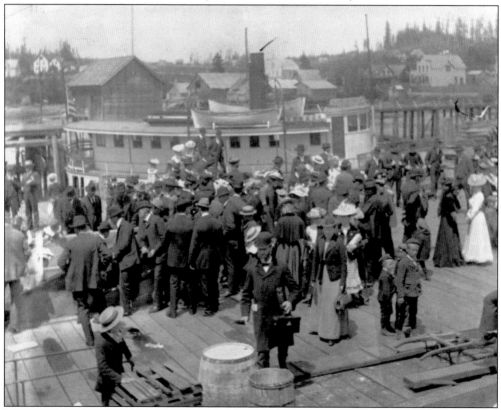

Many steamers served Poulsbo—*Quick Step, Hattie Hansen, Mayflower, Advance, Dauntless, Reliance, Sentinel, Kitsap, Hyak, Athlon, Liberty, Vashon II,* and *Verona*—but only one was fully built in Poulsbo, the *Advance,* shown here. Local boat builder Einar Nilsen built it for Thomas Hegdahl under the banner of the Poulsbo-Colby Transportation Company. The *Advance* proved to be a valuable addition for Hegdahl's company. The Hegdahl sawmill is seen in the background.

After enduring years of poor service in this cutthroat business, the *Athlon* was purchased by the trustees of the Liberty Bay Transportation Company, formed in 1914 by Poulsbo residents and area farmers. But by 1919, with the Liberty Bay Transportation Company facing bankruptcy, the *Athlon* was sold to a private owner, John Seierstad.

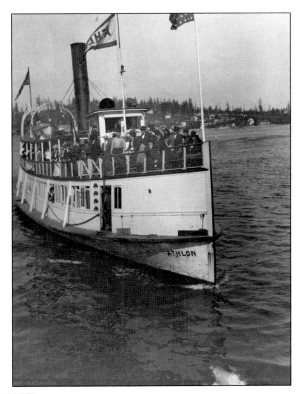

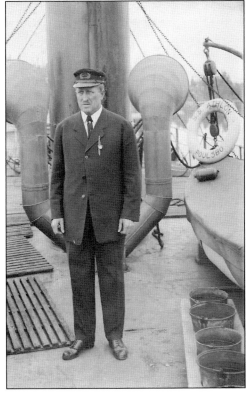

Investors in the *Athlon* hoped to be able to have some control over schedules, fares, and freight charges, but instead, a steamboat war erupted that continued for eight years. It caused a division in Poulsbo with lasting effects that helped form the town's character. Capt. Walter Primrose piloted the *Athlon* for the Liberty Bay Transportation Company.

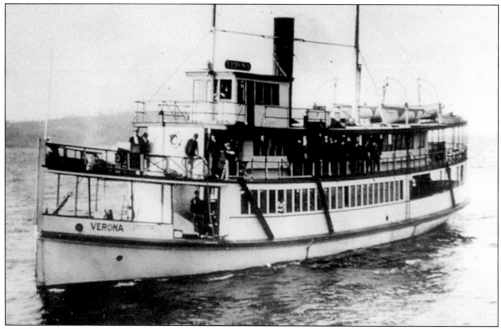

In 1920, ten Poulsbo men formed the Union Navigation Company and bought the steamer *Verona*. They leased the vessel to the newly formed Poulsbo Transportation Company in an attempt to compete with the Kitsap County Transportation Company. However, one disaster after another drove the Poulsbo company to bankruptcy. The Union Navigation Company had no choice but to sell the *Verona* to the Kitsap County Transportation Company in 1923.

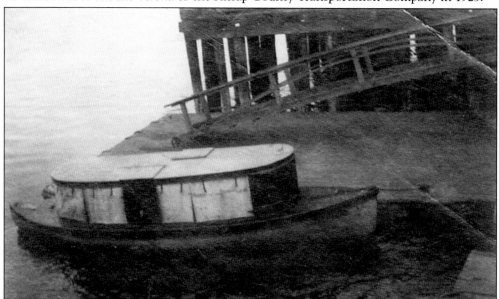

Small privately owned launches, like the *Josephine L* belonging to newspaper editor Peter Iverson, zipped around Dogfish Bay even after the steamers began docking in Poulsbo. In addition to aiding his own business needs that could not always wait for the scheduled steamer, Iverson used the *Josephine L* to supplement his meager newspaper income by running small contract jobs for local businessmen and farmers.

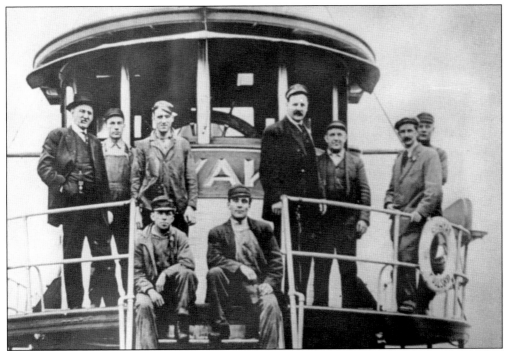

The *Hyak*, the flagship of the Kitsap Transportation Company line, was considered the most beautiful steamer of the mosquito fleet. Capt. Henry A. Hansen took pride in keeping her brass polished and shiny. Other steamers operated by the Hansen family included the *Quick Step* and the *Hattie Hansen*. Shown are former captain Henry Hansen (far left) and his brother, engineer Ole Hansen (center, in uniform).

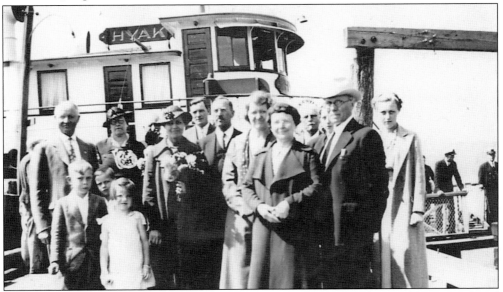

The Kitsap County Transportation Company took over the full run to Poulsbo in 1923 and provided fairly reliable service for several years. The *Hyak* and the *Vashon II* made two round-trips per day to Poulsbo until 1937. On March 26, 1937, a notice appeared in the *Herald* that the *Hyak*'s schedule had been suspended until further notice. It was the end of the steamboat era.

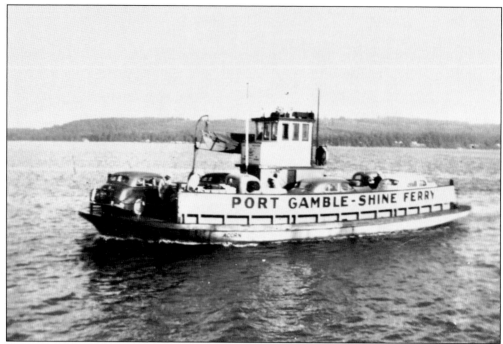

Ferry service to Kitsap County in the 1930s heralded the demise of the steamer era. The Port Gamble–Shine ferry *Acorn* provided service across Hood Canal. Poulsbo's ferry connection via Suquamish to Ballard began in 1923 and provided farmers easy access to their markets. When the Ballard ferry terminal moved to Seattle in 1937, Kitsap residents protested vehemently, but the protest landed on deaf ears. The terminal remained in Seattle.

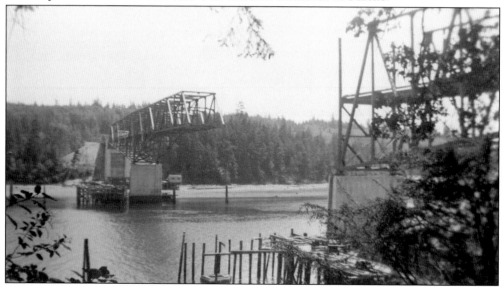

Transportation on the Kitsap Peninsula changed forever when the Agate Pass Bridge was completed in 1950. Poulsbo residents could travel to Seattle in half the time with a half-hour crossing from Winslow rather than a nearly two-hour run from Suquamish. The ferry system served routes from Kingston to Edmonds, Vashon to Fauntleroy, and Lofall to Southpoint, as well as the runs to Seattle.

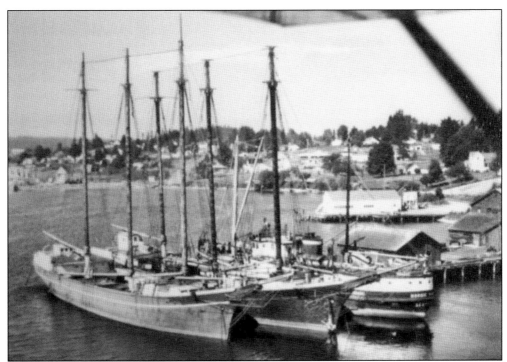

The Pacific Coast Codfish Company brought its headquarters to Poulsbo in 1911 and continued in business until the late 1950s. Here the *Charles R. Wilson*, *C.A. Thayer*, and *Nordic Maid* are docked at the codfish plant along Lemolo Shore Drive. Every April, the schooners headed for Alaska, and they returned in August or September with cargo holds full of salted codfish.

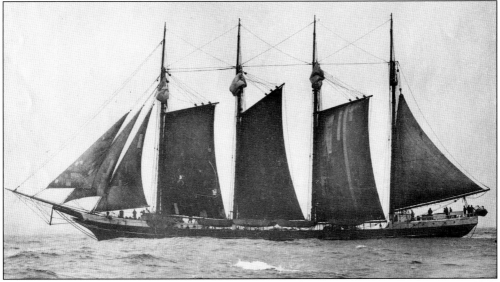

In 1933, the schooner *Sophie Christenson* returned from the Bering Sea with 455,000 codfish aboard. She was commandeered from Capt. Edward Shields by the government in January 1942 for the war effort and had the distinction of being the only US troop transport that actually carried sails during the war. The *Sophie Christenson* had 175 soldiers aboard at the attack on Attu.

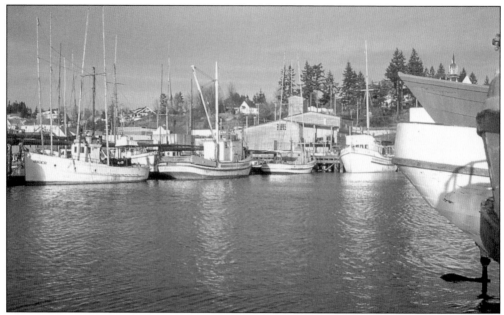

Poulsbo's harbor in 1952 displayed many types of fishing boats—purse seiners, trawlers, gillnetters, trollers, and set nets. The codfish fleet had its own wharf further down the bay. The purse seine required a skiff that pulled the net into a circle before the bottom was drawn tight. Trawlers dragged the bottom, trollers used long lines, and set nets were stretched out from the bank.

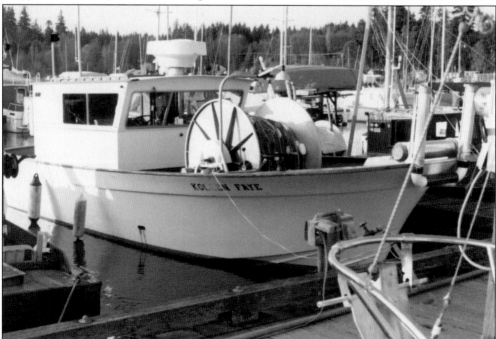

There are two types of gillnet boats, the bow picker and the standard gillnetter. The bow picker, true to its name, requires the fisherman to work in the bow of the boat. The boat backs away from the net, while the net is picked over the stern on the standard gillnetter. Gillnetters usually fish salmon, working alone or with one crewman.

Another popular type of salmon fishery is the troller. These long-line boats are rigged to catch the fish on hooks. The *New Day* fished out of Poulsbo for many years. Owner Dennis Kimmel established the New Day Fish Market and Eatery on Front Street. Later, the fish market moved to Port Townsend, where it continues to process the cod for many annual lutefisk dinners. (Courtesy of *Kitsap Sun*.)

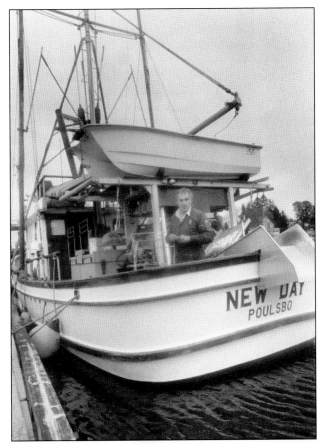

The *Evening Star*, a long-line boat, has a long history in Poulsbo. It still leaves Poulsbo in the early spring to fish Alaskan waters, not returning to its safe harbor until September. Many of these larger boats have fished for halibut, the lucrative king crab, herring, and pollock as well as salmon. The *Evening Star* has been skippered by Fred Peterson, Norris Lee, Arne Lee, and Andy Iverson.

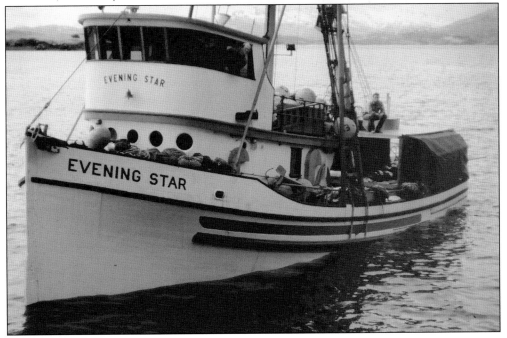

Ron Young (left), with Fred Langeland (center) and Chris Twedt (right), is probably the most well known of the Poulsbo boat builders. The son of Olympic Hotel owners Andrew and Christine Young, Ron began as a teenager developing the "perfect" design for a fishing boat that would be stable and easily maneuvered. Young built nearly 900 wooden Poulsbo Boats in his basement workshop.

When Ronald Young built a boat, he had two standards that could not be altered. First, the buyer had to pay cash for the boat to prove he could afford it, because Ron felt it was vital to be able to work hard and support the family first. His second standard was that he was a boat builder, not a painter, so the buyer had to paint the boat.

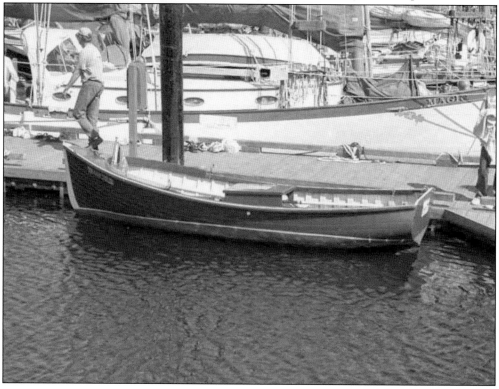

Families in Puget Sound have enjoyed Poulsbo Boats for many years, whether for fishing or just for a joy ride. Here the Maki grandchildren Chris Maki (left), unidentified, and Anna Maki (right) enjoy some solo time in their Poulsbo Boat. For many years, collectors held a Poulsbo Boat Festival at the docks in Poulsbo to display how they had painted and outfitted their Poulsbo Boats. (Courtesy of Irene Maki King.)

Because sport fishing was so popular and salmon were so plentiful in Puget Sound, small cruisers were in high demand. Glenn and Aubyn Ann Haskin enjoyed fishing aboard a Ron Young boat of a different design. Other successful boat builders in Poulsbo included Einar Nilsen, Chris Haugen, and Martin Bjermeland with his two sons, Hilmer and Edward.

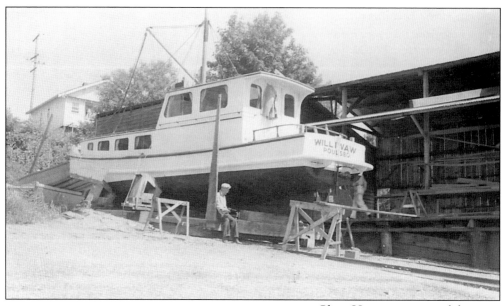

Chris Haugen was a prolific boat builder and repairer. About 1910, he bought tidelands south of the Poulsbo docks and constructed a boatshed and ways. Haugen built boats here until his death in 1968. A long list of boats testifies to his expertise. Roland Anderson was the last shipwright to use the Haugen ways. Leif Ness and his *Williwaw* are pictured on Haugen's ways in the 1950s. (Courtesy of Ness Collection.)

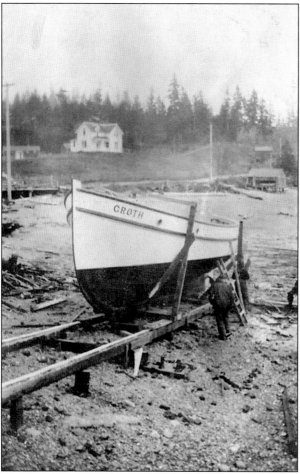

While the Poulsbo Boats could be built in Ronald Young's basement, larger boats required the use of a boatshed, or at least a track, known as a "ways," to move the completed boats into the bay or to bring them out above the tide for maintenance and repairs. In 1919, Martin Bjermeland built his ways south of town on Lemolo Shore Road, shown here in 1920. (Courtesy of Oyen Collection.)

Jergen Almos built the *High C* for Leif Ness. Here it is launching from the Almos Marine works south of town. Once a new boat was completed or a repair was finished, the tide directed the work. Boats were brought onto the ways at high tide. When the work was accomplished, the boat was returned to the sea on a high tide. (Courtesy of Ness Collection.)

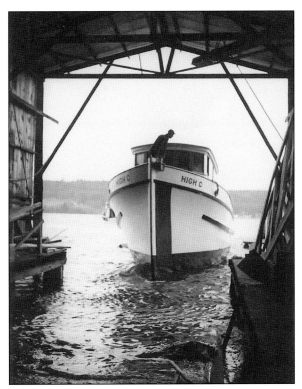

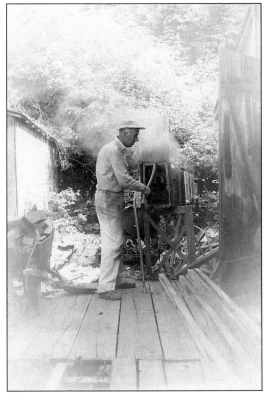

Boat building was a time-consuming craft mostly accomplished by hand. Boat builders took great pride in the finished product, and it showed in their work. Leif Ness is shown working with Ron Young's steam box on a piece for his *Williwaw*. The boat builders of Poulsbo were a congenial group, often working together on boat projects. Their considerable skills were in high demand around Puget Sound. (Courtesy of Ness Collection.)

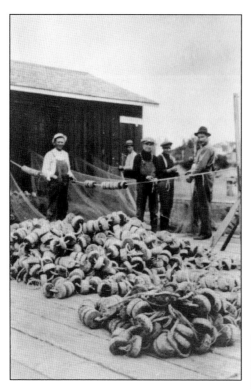

Fishing at sea is only part of a fisherman's life. Fishermen spend much of their time hanging new nets, rehanging old nets, repairing holes in nets, maintaining and repairing fishing boats, and, of course, that most highly prized activity—telling and retelling fish stories! Following the long and dangerous fishing season, the reward was sitting back to tell the harrowing stories. Here Poulsbo fishermen prepare their nets for the new season.

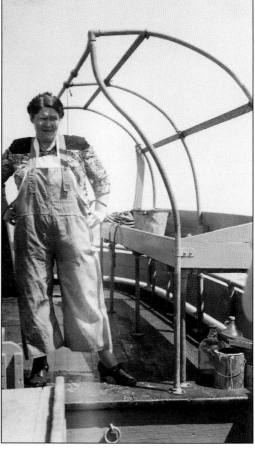

Fishermen are a superstitious lot and many considered having a woman aboard the vessel really bad luck. Not all fishermen held that belief, however, or Clara Peterson, shown here, would never have worked aboard the *Summit*. Some boats, such as the *Nordot*, owned by Norman and Dorothy Rustad, were husband-and-wife teams. A couple might spend several months a year living aboard their vessel. (Courtesy of Denise Bailey.)

Poulsbo has been the home port of many fishing boats. Liberty Bay provides a safe haven where boats are close enough for the fishermen to keep watch over them. Naming of a boat is serious business, especially for superstitious fishermen. Many were named for wives, daughters, and mothers. Usually, only the bigger vessels were given male monikers.

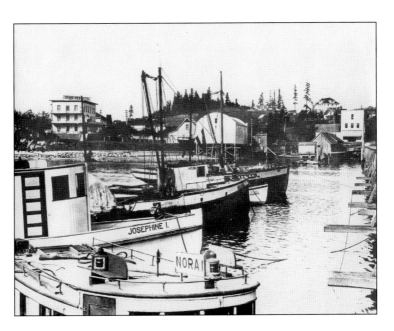

The fishing fleet had a tradition in Poulsbo. Once all provisions, tools, fuel, and nets were on board and they were ready to head north, families and friends would gather on the docks to say goodbye, knowing it would be several months before they would be together again. The pastors of the churches would also come to bless the fleet and pray for a safe return.

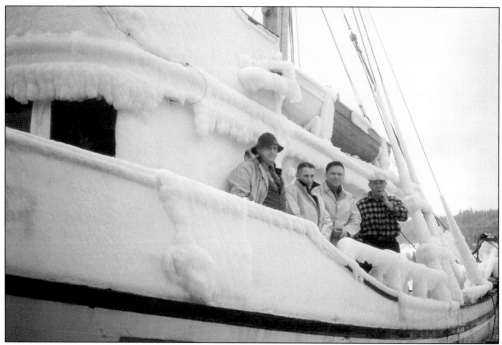

Fishing is always a treacherous business, and many fishermen do not return from the sea. In the Strait of Juan de Fuca, the *Evening Star* ran into a storm that really iced it up. This is especially dangerous, because instruments can fail and, should the fog settle in or a strong wind and heavy seas come up, the vessel and all aboard are in jeopardy. (Courtesy of Ness Collection.)

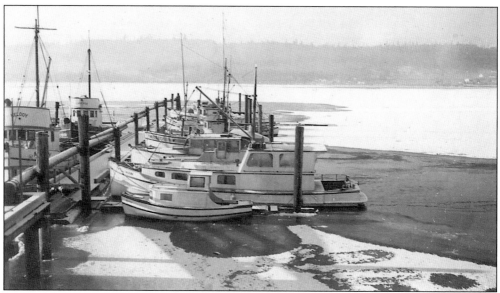

In January 1949, Liberty Bay iced over. In places, the ice was reported to be more than two inches thick. Capt. Fred Peterson of the *Evening Star* requested help from the Coast Guard to break up the ice so he could get out to set his shark nets. However, the sheet of ice was razor sharp and too dangerous for the wooden-hulled patrol boat.

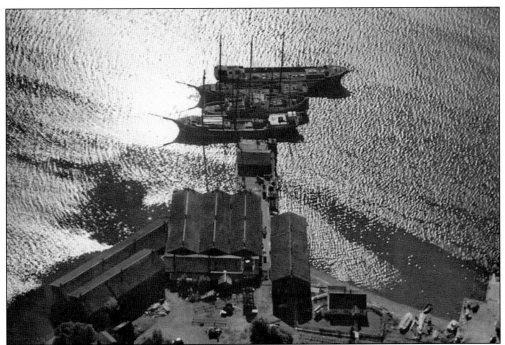

World-class cod fishing came to Poulsbo in 1911. The three- and four-masted schooners of the Pacific Coast Codfish Company were an impressive sight at the plant or entering Liberty Bay heavily laden with codfish in August or September. When the vessels were not fishing the waters of Alaska, they were found along the shores of the South Pacific. The schooners delivered lumber and returned with copra or other marketable products.

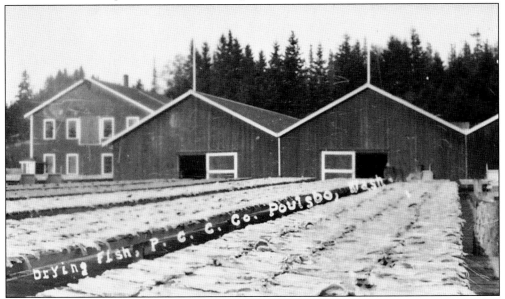

After the codfish was delivered to the plant, it had to be prepared for market. During its heyday, the Pacific Coast Codfish Company was the largest employer of both men and women in the Poulsbo–North Kitsap community. This was demanding work, and as much as 50 tons of dried cod might be brought in for processing.

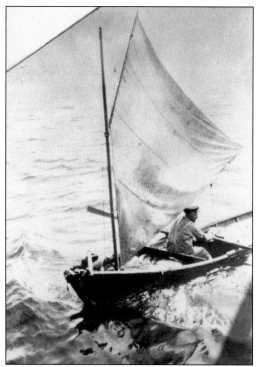

One of the most dangerous jobs on the codfish schooner was manning a dory. A fisherman would be alone on the high seas, jigging for codfish. If the fisherman was very successful or became too greedy, the dory could become too heavy with fish and capsize. The heavy oilskin raingear worn by the fishermen meant few could survive a fall into the icy Alaskan waters. (Courtesy of Oyen Collection.)

Crewmen on the *Sophie Christenson*, as on all the codfish schooners, worked very hard. Most codfish schooners had a crew of 35 to 45. Every job, from catching the fish to stowing it in the cargo hold, was critical and had to be accomplished correctly in order to preserve the codfish for the long trip back to Poulsbo. (Courtesy of Shields Collection.)

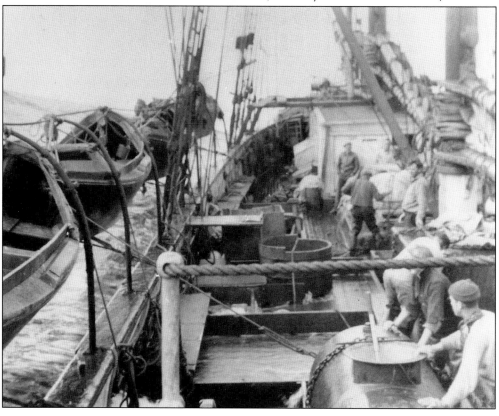

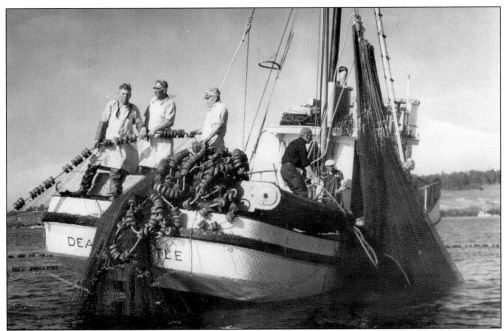

The *Dean*, a purse seiner, was fished in Alaskan waters by Poulsbo men for many years. It was originally skippered by Henry Antonson, then by Karl Kristensen, and after that by Karl's son, Paul. Besides salmon, the seiners fished for king crab, herring, and halibut. Many local men have been members of seiner crews over the years and happily delight listeners with tales of peril on the high seas.

Another gillnetter in the fleet was the *Kjerstena*. This vessel fished exclusively in Washington waters from the South Sound near Tacoma, throughout Hood Canal, up the Strait of Juan de Fuca, and into the San Juan Islands. Besides salmon, *Kjerstena* once fished for dogfish. While purse seiners fished daylight hours, the gillnet fleet fished from dusk to dawn. Most gillnetters prefer to fish alone.

In the 1920s, smelting was a commercial venture in Poulsbo, and the small fish were caught close to the docks in town. Following World War II, there were more than a dozen rigs in the smelt fleet, but by the late 1960s, smelting had basically become a sports fishery. Today, people gather in the fall to catch the small silver fish as they deposit their eggs along the shoreline.

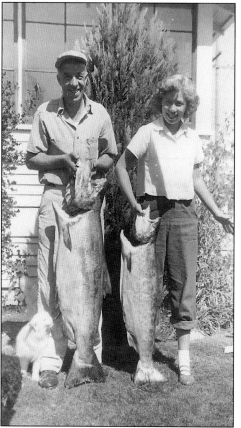

Sports fishing has always captivated the hearts of men, women, and children in Poulsbo. Leif Ness and his daughter Sonja display their catch of the day in the 1950s. More than likely these fish were caught off the *Williwaw*. It was not unusual to catch fish of this size, and the fish stories tended to grow each time they were retold. (Courtesy of Ness Collection.)

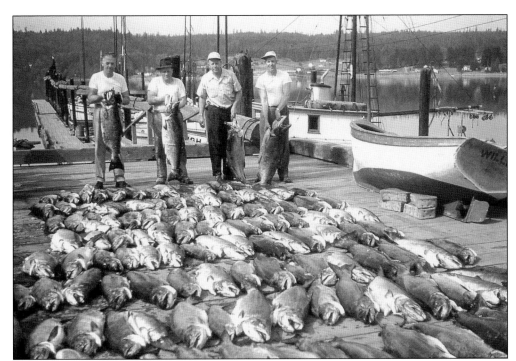

Salmon anyone? Early sports fishermen concentrated on Liberty Bay, Agate Pass, and maybe as far as Hansville, angling for salmon, ling cod, rock fish, flounders, bottom fish, dogfish, and perch. Once travel became commonplace, local fishermen made trips to Sekiu, Pillar Point, and even to the ocean to enjoy their favorite pastime. From left to right, Martin Anderson, Fred Peterson, Ole Serwold, and Bill Gee display the fruit of their labors. (Courtesy of Ness Collection.)

Local businessmen often took time out to try to catch "the big one." From left to right, Ole Berg, Ralph Nesby, and Chet Gausta proudly display their prize catches. There was a great deal of competition among the sports fishermen of Poulsbo. They would have a hook in the water as often as they could when fishing season was open.

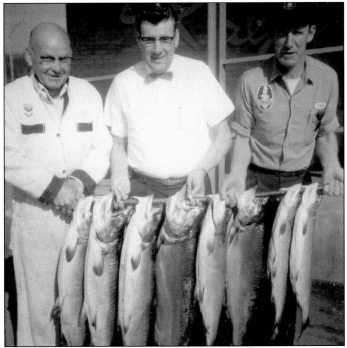

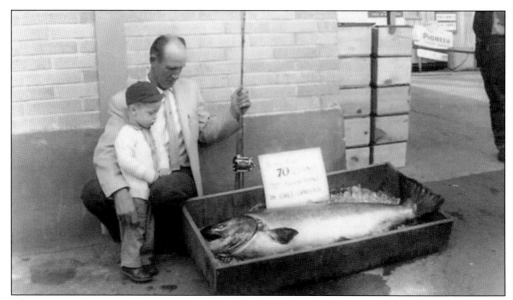

Chet Gausta, born and raised in Poulsbo, was one of the town's most famous sports fishermen. In 1964, he caught a record-breaking 70.5-pound king salmon on a rod and reel in Washington waters. The record stands today and, with current conditions and other restrictions, it will most likely hold for decades to come. Chet poses with an unidentified child in awe of the gigantic catch. (Courtesy of Mark Nesby.)

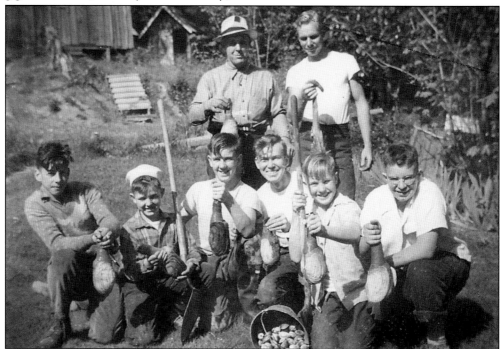

Fishing is not for everyone. At first glance, one might think these young men are displaying their fish. But a closer look reveals that they have geoducks, also called king clams. Only the hardy are successful at digging these huge creatures. The little clams in the basket are much easier to dig and, for that matter, much more succulent and easier to chew.

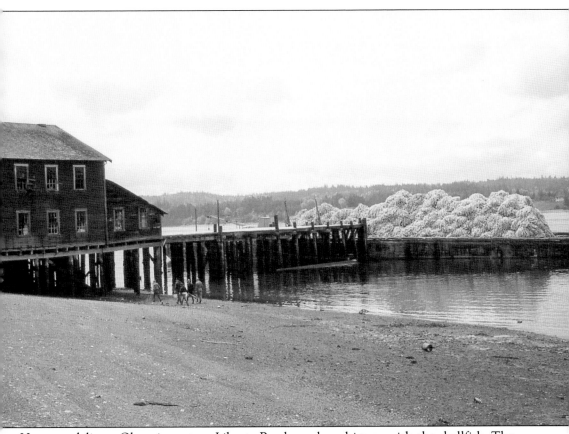

Home to delicate Olympia oysters, Liberty Bay has a long history with the shellfish. The Puget Sound, Eastern, and Olympia Oyster Companies controlled oyster beds as early as 1900. Operating under names like Haines, Coast, Keypoint, and Sea Farms, the plant stood near the codfish plant. Oyster shucking and packing took place there. Seed shells piled on barges await replanting in the bay and Hood Canal. (Courtesy of Ness Collection.)

A discarded Cedar Lane Oyster Plant sign recalls the former oyster plant of Alfred Lycell at the head of the bay. Although smaller in size than the plant south of town, Lycell's plant had a contract with Hilton Oyster Stew Company. He included a shell processing operation to crush shells for chicken feed.

Two

LAND
OUR REFUGE

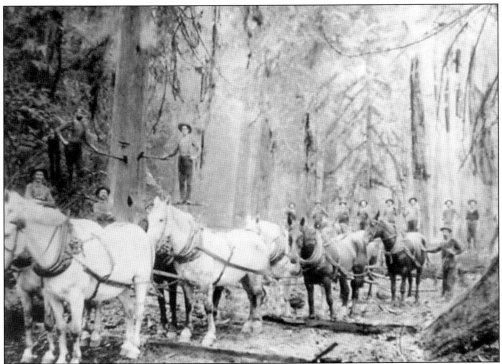

Poulsbo's earliest industry was logging. Trees grew so close together that the earliest loggers felled trees directly into the bay. Steep hillsides near the bay became skid roads for falling trees. After loggers cleared the shores, ox teams were floated ashore on rafts to haul logs from more distant land to the bay. Teamsters drove the oxen while a "grease monkey," often a nimble boy, darted ahead and greased the skids with dogfish oil, allowing the logs to slide more easily. In the bay, logs were gathered into log booms and towed by steamer to Meigs' Mill at Port Madison. Logging was dirty and dangerous work but lucrative for early settlers. This photograph shows a variety of logging operations. Springboard sawyers stand high on the tree to cut where the tree's grain was straightest.

Independent logger Paul Wahl arrived in Big Valley in the 1870s. He single-handedly built numerous roads, trestles, and bridges in the valley to more easily transport his logs to the bay. Wahl's log dump near today's Poulsbo was commonly known as Paul's landing. After leaving the valley, Paul Wahl logged in King and south Kitsap Counties. Subsequent loggers made good use of Wahl's logging roads.

A log chute was used by the Myreboe logging crew in the Vinland area. This was another way to move logs to the water. A man can be seen standing on the front log in this chute. Floating cabins on rafts tied along the shore commonly housed logging camps. They were easily moved from site to site, providing cook house, laundry, and sleeping quarters. (Courtesy of Dale Anderson.)

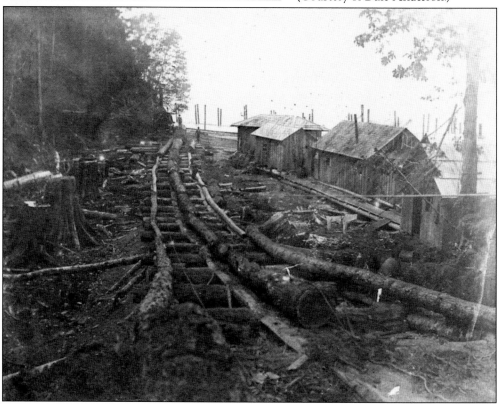

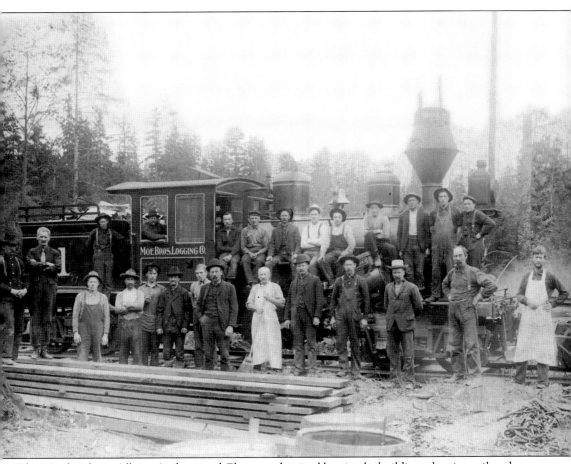

The Moe brothers, Albert, Andrew, and Chris, modernized logging by building a logging railroad in Big Valley and dumping their logs into Hood Canal to be towed to the Puget Mill Company in Port Gamble. The Moes bought two train engines, laid rail, and established the county's first logging railroad. Traces of old logging roads and the railroad bed can still be found in Big Valley. (Courtesy of Randy Foldvik.)

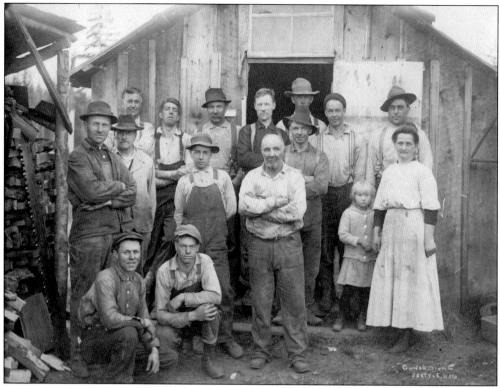

The Paulson logging crew posed for the camera about 1924. Norwegian-born Peter Paulson, seen here at left leaning against a wood shed post, came to Poulsbo about 1907 and logged on Lincoln Hill east of Poulsbo for over 20 years. It was a family affair, as son Clarence (in the floppy hat) stands to his left, and daughter Helen holds Agda Paulson's hand.

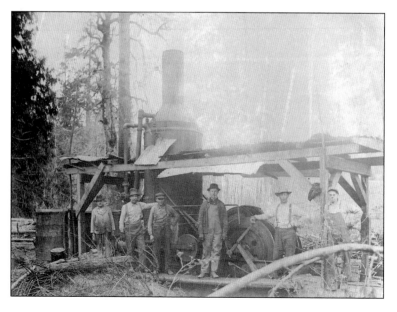

Peter Paulson, standing at center with his pipe, used a steam donkey engine to winch logs to the log stack for transport. Donkey engines, fired by plentiful wood scraps, were commonly used in the area's logging operations. They were easily pulled through the woods and saved hours of back-breaking work when hauling logs.

Another invaluable piece of machinery in the woods was a log crane. Here, two cranes are working in tandem. The taller crane pulls logs from the forest floor to the loading pile, while the smaller one is loading logs onto sleds ready for transport. Each crane appears to be fired by a separate steam boiler.

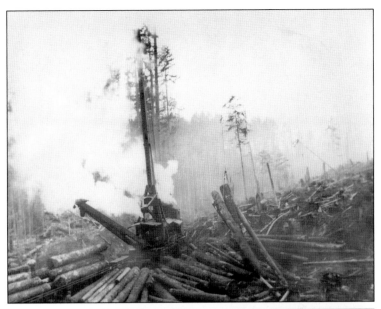

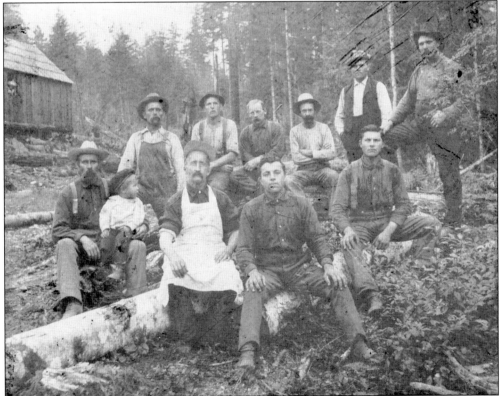

Loggers came in all shapes and sizes. Haldor S. Myreboe holds his son, Selmer, at his logging camp in Vinland in the 1890s. Notice the fancy hat worn by Susan Myreboe as she peeks from the window of the cabin on the left. The Myreboes left logging in 1905 and moved to Poulsbo, where Haldor became a prominent businessman. Selmer served as Poulsbo's mayor in 1925 and 1932. (Courtesy of Dale Anderson.)

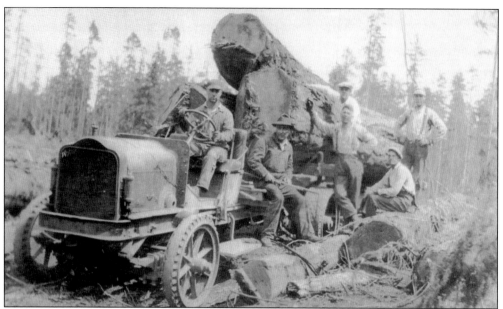

The expansion of the automobile industry into the field of heavy equipment in the 1920s lightened the load for loggers with the introduction of logging trucks. This load proves that there were still giants to be felled in North Kitsap woods following World War I. From left to right are Harry Evenson, Norman Oen, Bill Jacobson, Henry and Oliver Birkeland, and Clarence Itjeo (seated at right).

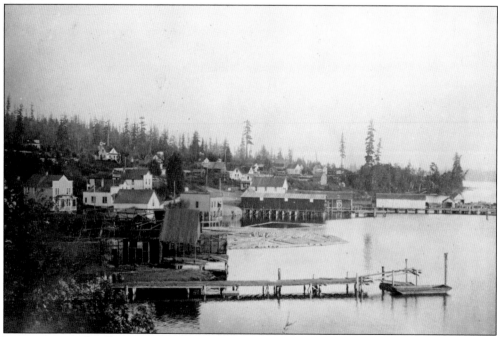

Loggers required mills. By 1891, a sawmill was located on the banks of Dogfish Bay across from the Hostmark store. Owned by brothers Thomas and Ole Hegdahl, it was sold in 1901 to Arne T. Arneson, who moved it south of the settlement in 1905. Remnants of the Hegdahl mill are seen in the foreground of this 1907 photograph of Poulsbo's waterfront.

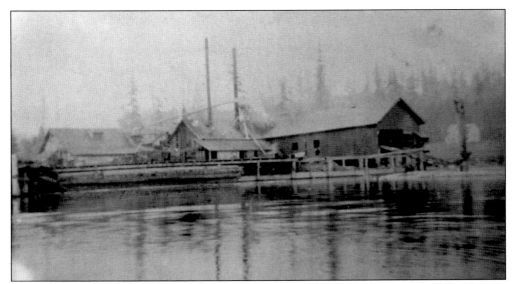

The Arneson mill, moved from downtown Poulsbo in 1905 and rebuilt near today's Lion's Park, made cut lumber and shingles and supplied spars and knees for Puget Sound ship builders. By 1910, the ready supply of logs in the Poulsbo area was mostly depleted, and both mills on the bay closed.

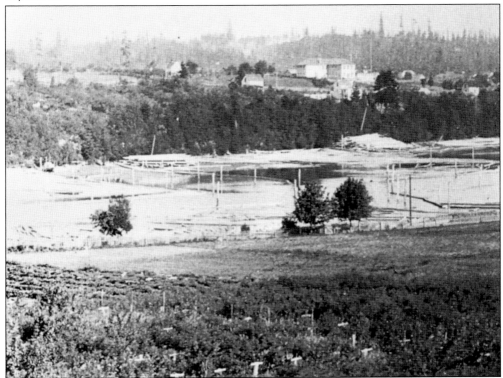

Einar Nilsen operated a shingle mill at the head of the bay. The shallow water was not well-suited to floating out the lumber, and Nilsen was more interested in carpentry than in milling. He kept selling his mill, only to have the buyer go broke and return it to his ownership. Logs from the mill operation rest on the mudflats at the head of the bay in this 1910 photograph.

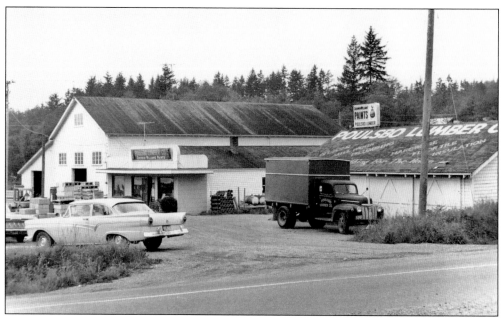

In 1920, Nilsen sold his mill to August Nelson and Ole Olson. They renamed it Poulsbo Lumber Company and parlayed it into a thriving lumberyard and contracting business for over 60 years. The partnership was joined by Arthur Ryen, Olson's brother in law, in 1926. Ole's son Donald succeeded his father in the business.

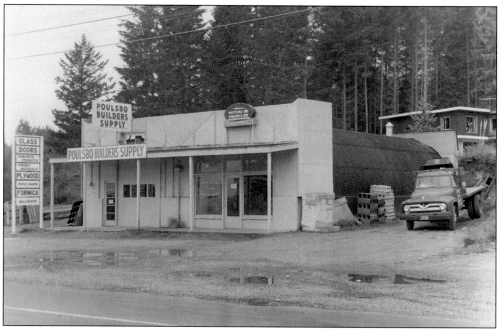

Entrepreneur Vince Prouty partnered with Wesley Settle of Settle Construction Company to open Poulsbo Builders Supply in a Quonset hut following World War II. As the business grew, the partners moved across the street, added Junction Electric Company to their holdings, and became Junction Builders Supply. The business was sold in 1975 to Harry James, who moved it farther south, renaming it James Lumber. James Lumber remains in business today.

As trees disappeared from the land, tall stumps dotted homesteaders' fields. Clearing these stump farms was the first order of business for Poulsbo's farmers. It was a dirty but necessary business to tame the wilderness. Whether farming a large acreage or a small town plot like Nels Olson's, shown here, agriculture surged in 1900, with fruit, dairy, and poultry farms being the most popular. (Courtesy of the Ark.)

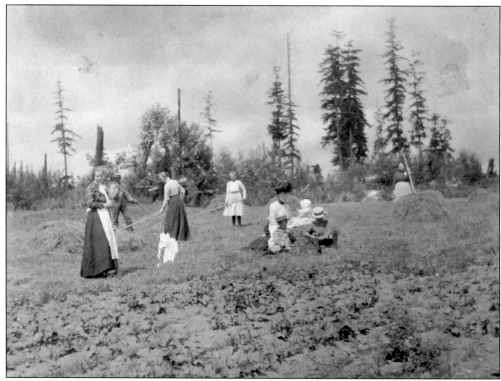

In Puget Sound's fertile soil and moist weather, any twig stuck in the ground might sprout. Farmers continually fought back the natural vegetation (blackberries, fireweed, foxglove, salal, alder, and maple trees). In the Martin Hansen family on Pearson Point, all hands helped clear the field for planting. Known workers are Martin (second from left), daughter Anna Catherine (standing at center), and Thorine (far right).

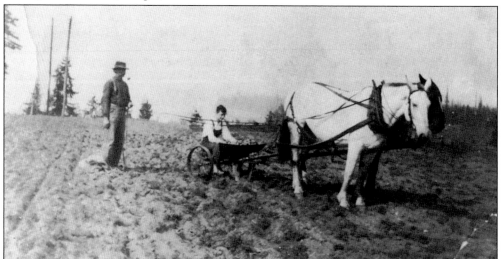

Another family operation was that of the Nils H. Oen family of Vinland. When the Oen sons, Helmer, Adolph, and Norman, were in the service during World War I, Nils's daughter, Alice, helped harvest the family's potato crop by sitting in the cart and gathering the ripe tubers. Nils holds the reins while driving the team.

44

Local climate and soil was also found to be perfect for fruit orchards, strawberries, raspberries, and blueberries. Swedish-born Frank Peterson guides the plow while his son Ray handles the horse reins in their field of Marshall strawberries in the Lemolo area of Liberty Bay. Marshall strawberries were, and still are, considered the local favorite on the berry market. (Courtesy of Snouaert Collection.)

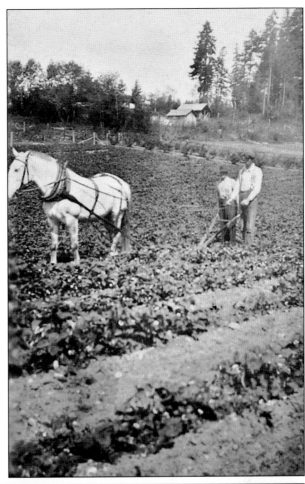

At harvest, pickers lined up with cartons and flats to nip the berries from the plants. Pickers on the Peterson farm were, from left to right, Axel Noll, Ray Peterson, Alice and Olive Noll, Richard and Ethel Peterson, and Alice Twedt. The Nolls and Twedts were neighbors of the Petersons. Until pesticide regulations stopped them, berry picking was a popular employment for youth in the summer. (Courtesy of Snouaert Collection.)

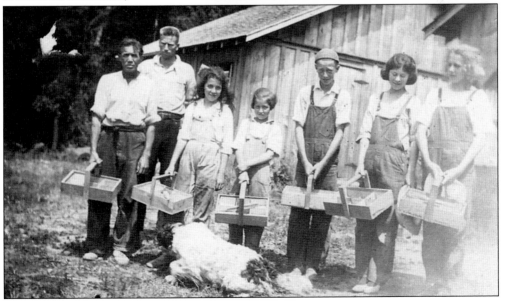

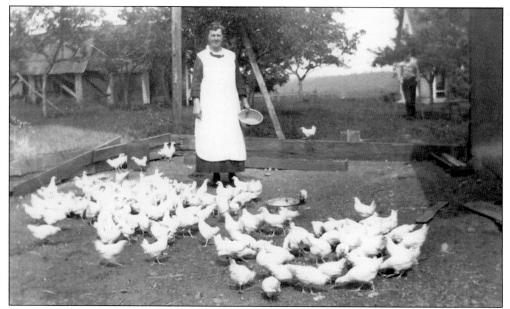

Dairy and poultry farming was a stable income for local families, furnishing milk, cream, butter, and eggs for home needs or for sale in local markets and in Seattle. For fishing families with uncertain incomes, dairy and poultry farming provided a steady income. Taletta Torgeson kept chickens to furnish eggs and meat for her family at her home near the head of the bay. (Courtesy of Stenman Collection.)

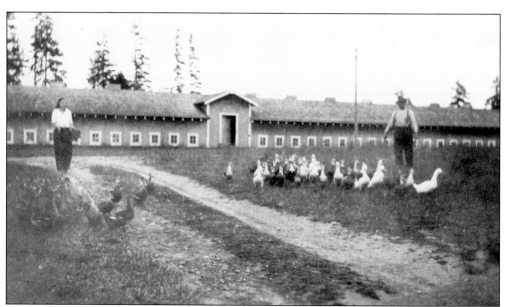

The Stottlemyers on Lincoln Hill had a 250-foot-long poultry house on their farm. Here Wallace and Ellen Stottlemyer tend their flocks of ducks and geese, proving that chickens were not the only poultry treading the farms of North Kitsap. In addition to poultry, the Stottlemyers also farmed strawberries and Christmas trees. (Courtesy of Frank Stottlemyer.)

Grandma Karen Anderson from Bergen, Norway, the wife of Sami-born Michael Anderson, lived on the west side of Liberty Bay and put her chickens to full use. In addition to gathering eggs, she raised some chickens for eating. Early housewives saved the feathers from the plucking for stuffing pillows in their homes. (Courtesy of Hanson Collection.)

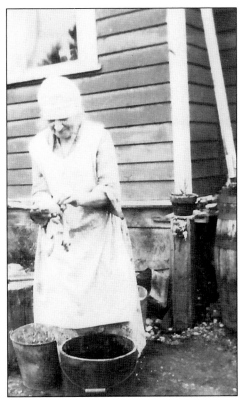

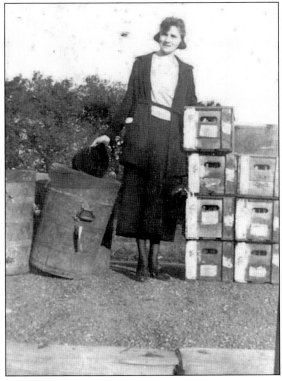

When the egg gathering, berry picking, chicken plucking, and butter churning were finished for the week, the wives around Liberty Bay crated up their goods and headed to the nearest steamer dock early on Saturday morning. They rode the steamer to Seattle to sell their produce and butter at the Pike Place Market or to businesses and neighborhoods in Seattle. It was a time of selling, shopping, and sociable chatting.

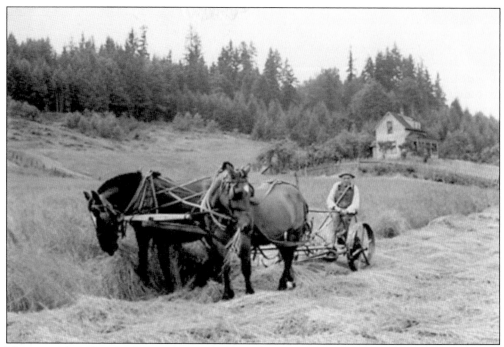

Norwegian-born Ben Malme cut hay on his dairy farm near Poulsbo with his horse-drawn mower. With the rise of automated milking machines and large dairy producers, the small dairy farms of the Poulsbo area closed. The Malme farm was located at the site of today's Poulsbo Village shopping center. After Ben Malme's death in 1954, the farm became Poulsbo's golf course, owned by Vincent Zuarri.

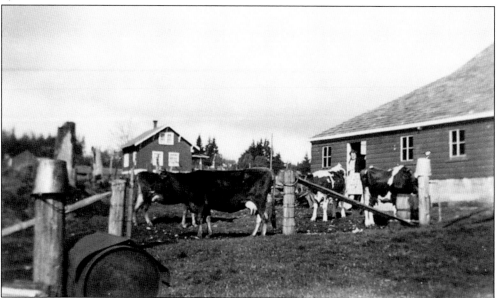

The Hjalmar Rudes on Finn Hill were typical general farmers. Hjalmar had two occupations, logging and farming. He relied on his wife, Johanna, seen here on the steps of the barn, to help out with the farm when he was at the logging camps. The Rudes had a few cows, a coop of chickens, and even a couple of goats on their small farm. (Courtesy of Rude Collection.)

Julius Hansen, at his farm on Finn Hill, forked hay into his hay loft with the aid of a more modern piece of farm equipment, a truck. Julius had a dual career. He was a deep-sea fisherman during the fishing season and a general farmer year-round, a pattern followed by many area men. (Courtesy of Dietlein Collection.)

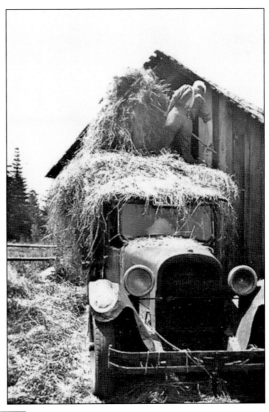

Annie Ainaly, a dairy farm wife of Big Valley, heads to the milk house with her milk pitcher for one more bit of milk for her baking. Farm wives were used to taking over the responsibilities of the farm when their men were fishing or logging. In addition to her house and farm duties, Annie was the mother of nine children. (Courtesy of Dove Collection.)

Breidablik and Big Valley were dairy farm lands. William Stenman of Breidablik has his hands full of milk pails as he prepares to do his day's milking. In 1915, area farmers formed a cooperative creamery in Poulsbo. The creamery produced award-winning butter and ice cream, but stiff competition from larger creameries in the county and the hard times of the Depression ended the experiment in 1930. (Courtesy of Stenman Collection.)

The Kitsap County Cooperative Association was Kitsap County's most successful co-operative effort. Formed in 1905, the co-op continued in business as the farmer's friend until 1959. The co-op furnished seed grains, feed, nursery stock, farm implements, gasoline, clothing, and groceries—anything a farm family might need. Co-op members received dividends each year. The co-op's long life was testimony to its fair business practices and the loyalty of its members.

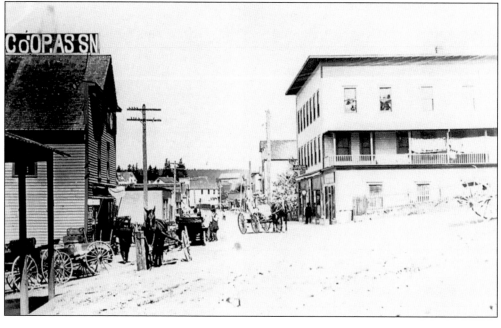

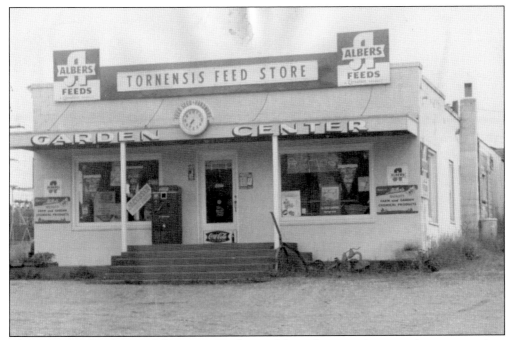

The Tornensis Feed Store did not enjoy as long a life as the co-op but served as a convenient farm, garden, and hardware store for farmers living on the west side of Liberty Bay, saving them the extra two miles travel time into downtown Poulsbo. The Tornensis family was a prominent part of Poulsbo's well-known Sami community, having come to Poulsbo in 1901 after herding reindeer in Nome, Alaska.

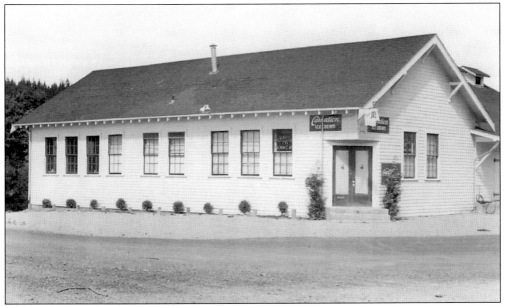

Erik, James Sr., and James Jr. Morgenson opened the Triple M Dairy at the head of the bay in 1947. The dairy, with its fleet of collection and delivery trucks, bought milk from a few local farmers but found many more in Jefferson County. It produced the first pasteurized and homogenized milk in Kitsap County. The dairy was sold in 1953, and the name was changed to Vita Rich Dairy.

Soren P. Jensen opened Jensen's Creamery and Ice Plant in 1929 midway between downtown Poulsbo and the head of the bay. It was a successful operation that the Jensens ran until they sold it in 1943. S.P. Jensen was not one to let grass grow beneath his feet. He was elected mayor of Poulsbo in 1938 and served in that capacity for 14 years. (Courtesy of Paulson Collection.)

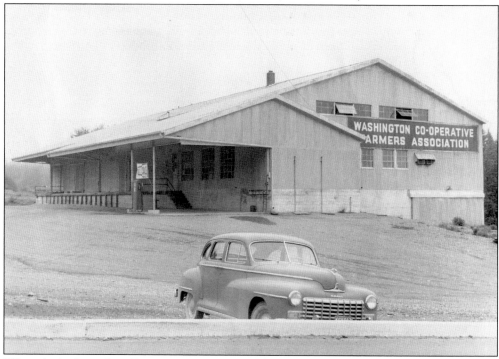

When the highway from Bremerton to Port Gamble opened in the 1930s, businesses were quick to open at Poulsbo Junction. One of the earliest was Highway Farm Supply. To the north was the Washington Cooperative Farmer's Association. The name was changed to Western Farmers Cooperative and finally today's Cenex Cooperative, but the cooperative farm business has remained remarkably constant, as seen in this photograph from 1952.

Three

COMMUNITY
OUR STRENGTH

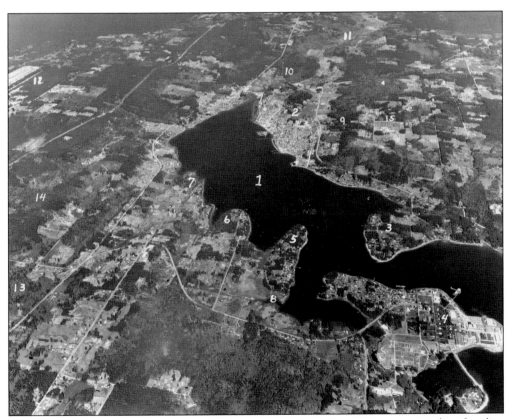

Poulsbo is the center of activity in North Kitsap, but many small communities are gathered within a five-mile area around Liberty Bay. Collectively, they are known as Poulsbo, and in this collection is the town's strength. Loosely identified by map numbers are 1. Liberty Bay, 2. Poulsbo, 3. Lemolo, 4. Keyport, 5–7. Scandia-Pearson, 10. Big Valley with Breidablik on the west, 12. Vinland and Bangor, and 11–15. Lincoln.

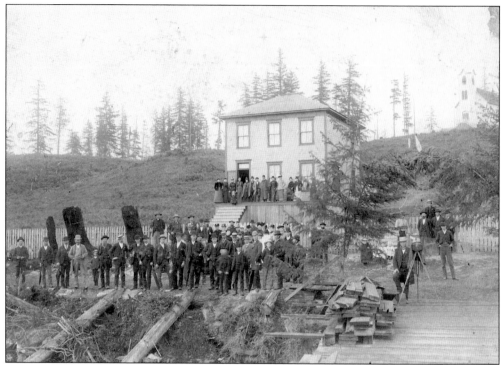

Poulsbo incorporated as a town in 1908. By that time, it had been settled for nearly 25 years. This early photograph was taken at the opening of Capt. John J. Hansen's Olympic Hotel in 1891. Fordefjord Church can be seen in the background. In the foreground, a new town dock has just been completed. The timbers on the bank may have been skids for an early logging camp.

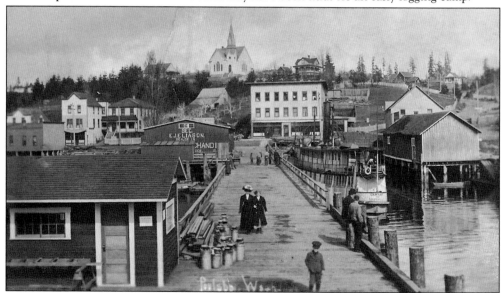

The same view from a slightly farther distance in 1909 reveals the growth of the town over 25 years. The Olympic Hotel is on the left with its annex, and the Fordefjord Church has been rebuilt into a larger facility. The large building across the street from the dock is the Eliason building and post office owned by Elias J. Eliason, the son of town father Jorgen Eliason.

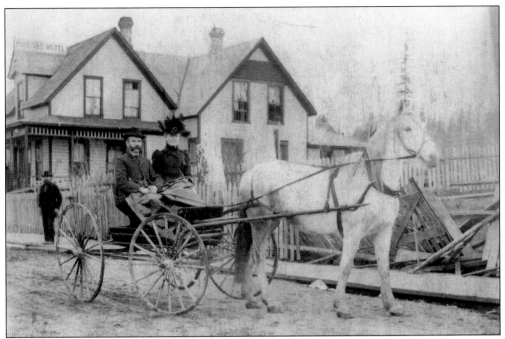

The Poulsbo Hotel was owned by Thomas Hegdahl and his wife, Caroline, shown here in their carriage with the hotel behind. The Hegdahl brothers, Thomas and Ole, established a saw mill across the street from the hotel in 1890. They also ran a furniture store near the mill. Family illness forced Thomas Hegdahl to move to Ballard in 1905. Standing on the sidewalk behind the Hegdahls is Nels Olson.

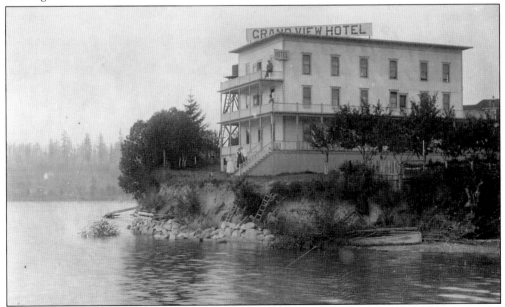

Poulsbo had three hotels. The Grandview, shown here, was the third one. It was built in 1907 by local builder Einar Nilsen for Nels Sonju, who declared it to be the finest hotel in Poulsbo. No one argued that point with him. The hotel provided conference rooms, nursing rooms for local doctors, extensive livery service, and a dining room. Standing on north Front Street, it was razed in 1968.

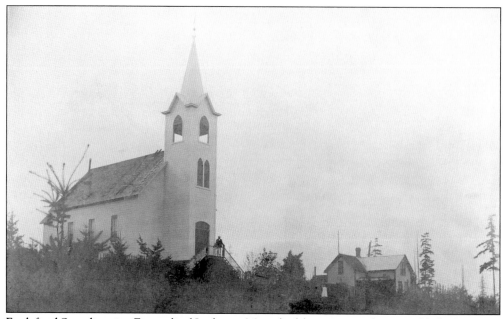

Fordefjord Scandinavian Evangelical Lutheran Menighed (congregation) was established in 1886. It is the oldest Lutheran church on the Olympic Peninsula. This first building was completed in 1890. Standing on the steps is Nels Olson, brother-in-law to Jorgen Eliason. Eliason donated the land for the church and cemetery from the corner of his homestead. Olson's home is seen just south of the church.

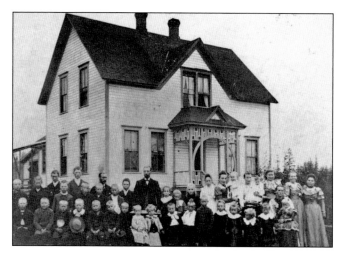

Martha and Mary Children's Home, pictured at left in 1894, was founded in 1890 by Rev. Ingebrigt Tollefsen, son-in-law of Iver Moe. An orphan himself, Tollefsen was concerned about the number of orphans in Puget Sound and children living in single-parent homes. He organized a consortium of Lutheran churches into the West Coast Lutheran Schools and Charitable Association, still in existence today. (Courtesy of the Ark.)

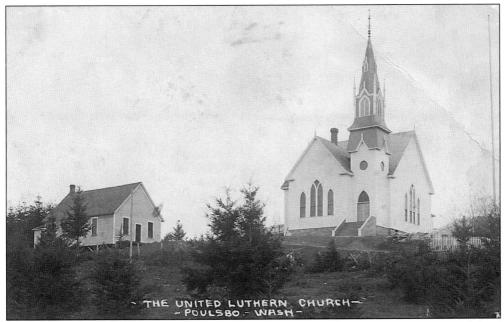

In 1908, its building in need of repair and much too small for the growing community, Fordefjord Lutheran tore down its church and salvaged the lumber to incorporate into this larger facility. This church remains today, with some modifications and additions. Its position overlooking the town makes it the iconic symbol for Poulsbo, and it has continued as a house of worship for over 125 years.

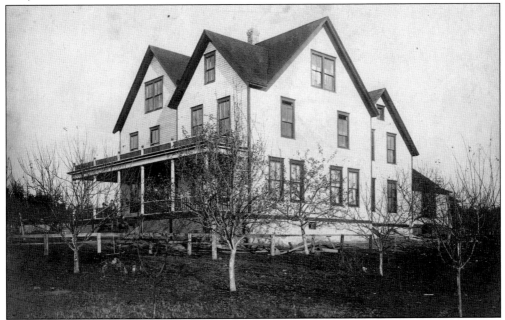

Martha and Mary Children's Home continues today. It is still owned by the same association, with a new focus as a nursing care facility. It includes a day care center for children and senior housing. Shown here in 1915, the home served children until 1954. By then, improved safety and health had lessened the need for a children's home. (Courtesy of Martha and Mary Collection.)

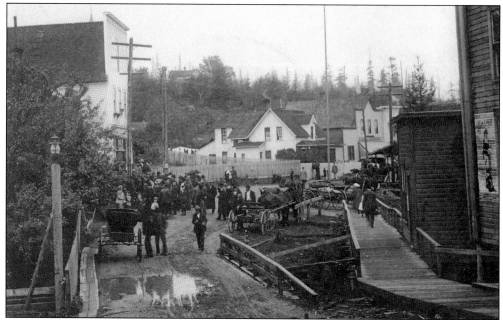

Photographed in 1911, a double bridge crossed a narrow ravine on Front Street. The ravine was filled in 1912. A creek at its bottom, put in a culvert, still troubles Poulsbo's waterfront. On the left is the Hostmark building (still standing), the Gronning residence (formerly Poulsbo Hotel), and Langeland's Dry Goods. The building on the far right, advertising a production of *Faust*, is the Poulsbo Athletic Club, also still standing.

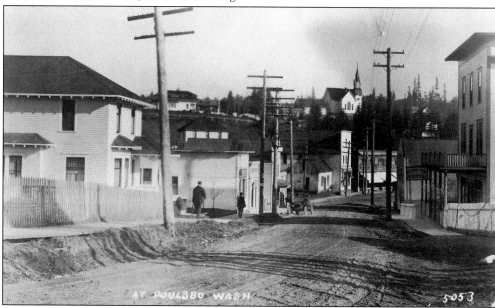

Front Street was photographed in 1915, after the ravine was filled. From left to right are Einar Nilsen's house, a photography studio, Liberty Bay Bank, and Bjermeland's building. The tall building at the intersection is the Hostmark building. The attached shack was an old logging shanty. The brick Liberty Block was built early in 1915. Across the street are the Poulsbo Athletic Club and the Grandview Hotel.

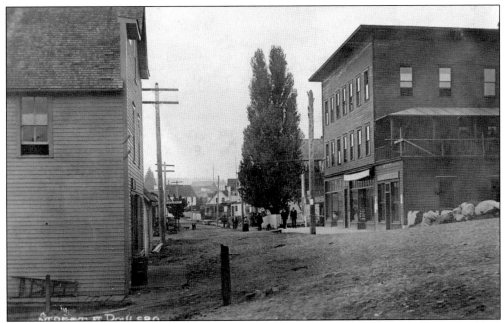

A look at Front Street from the south in the spring of 1908 shows the unpainted Eliason building on the right with the small post office. The tall poplar tree in front of the Olympic Hotel was a landmark on the street until 1910, when it was cut to make room for wooden sidewalks. On the left is the Kitsap County Cooperative, which later moved into the Eliason building.

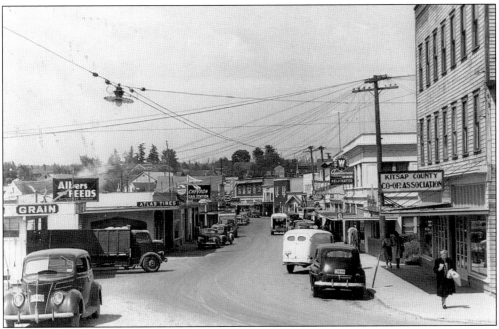

Nearly the same view, taken in the 1940s, shows a larger, busier Front Street. A devastating fire in 1914 destroyed the block north of the Eliason building on both sides of the street. After the fire, the buildings were replaced with cement structures, seen here. The Eliason building on the right, a fire survivor, is one of two remaining wood buildings on south Front Street.

Len's Café, shown in 1934, was popular. Fifty cents bought a hamburger and milkshake with enough change left for the movie. In the doorway are owners Alice and Leonard Haskin. Watching from the corner is their son, Glenn, who was raised in the apartment above the store. During World War II, Len's Café made hundreds of sack lunches each day for workers at Keyport Naval Station. (Courtesy of Mark Nesby.)

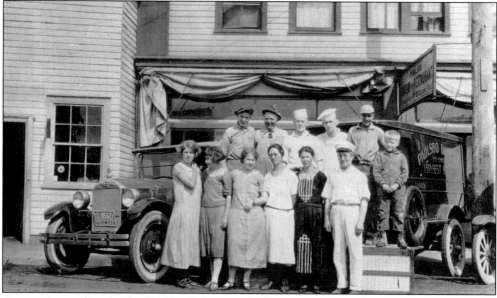

Anton Hansen bought the Poulsbo Bakery in 1915, moving it from the Liberty Block into his newly built building in 1918. From left to right are (first row) Clara Gronning, Clara Danielson, Laura Miller, Ida Coleman, two unidentified, and Arne Hansen; (second row) John Danielson, unidentified, Harry Hansen, Anton Hansen (baker's hat), and Alfred Danielson. The bakery could produce 6,000 loaves of bread daily and delivered throughout North Kitsap. (Courtesy of Ray Iversen.)

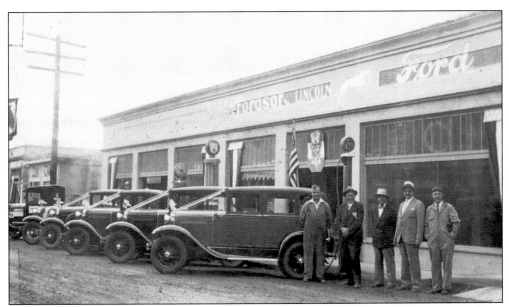

Several name changes were attached to the automobile dealership on Front Street—Paulson-Hostmark-Borgen, Hostmark Motors, and Bartlett Motors—but the brand was always Ford. Shown here on July 4, 1930, from left to right are Tom Torgeson, Pres. Ole Hansen, manager Hal Knudson, Capt. Alfred Hostmark, and George Knudson. George later bought the business, renaming it Knudson Motors. When Knudson retired, it became Casey Ford. (Courtesy of Ernie Knudson.)

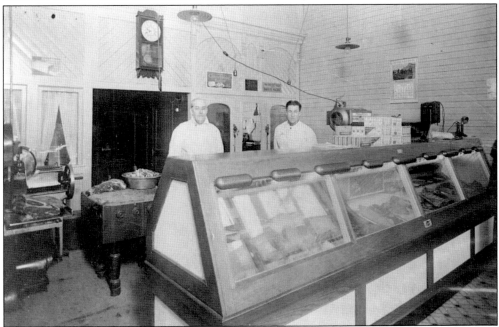

Poulsbo Meat Market was the oldest business in town under a single ownership at its closing in 1960. Tenander Iversen opened the business in 1903. At his death, sons Clifford, Rudie, and Arthur continued the operation. The Iversens were famous for their lutefisk, said to be the best in Puget Sound. They offered personalized service, helping customers plan menus and providing recipes along with their meat orders. (Courtesy of Ray Iversen.)

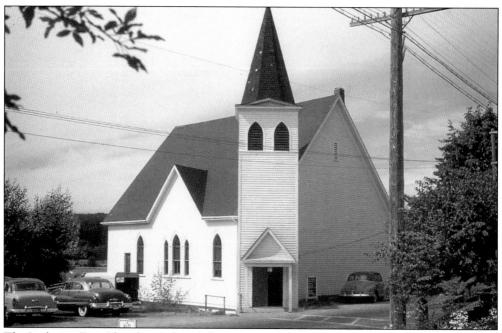

The Lutheran Free Church was founded in 1897. At that time, it met on the main floor of Iver Moe's house. This building was constructed in 1905 and served the congregation until 1968, when dwindling membership brought a merger with Vinland Lutheran Church on Finn Hill. When the Lutheran Free Church joined the American Lutheran Synod in 1955, the name became Grace Lutheran. Today, the building is the Gran Kirk condominium.

North of the Lutheran Free Church, Front Street curves, and the building that stood for 40 years on that curve was Poulsbo Grade and High School, seen here. The property was just north of the children's home. In 1930, the building was torn down, the lumber used for the Lincoln School (which had burned), and a new brick building was built on this site, the home of Poulsbo Union High School.

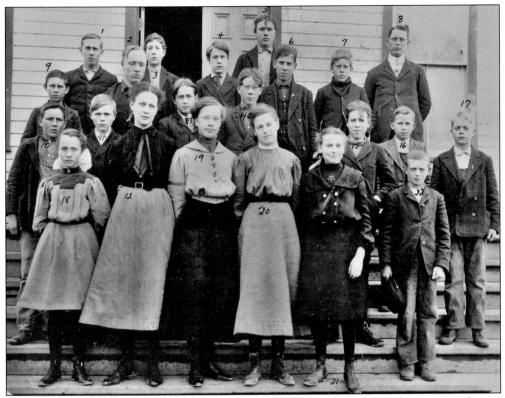

The students of 1907 identified by number are 1. Odin Johnson, 2. Edward Iverson, 3. George Bjermeland, 4. Roy Foster, 5. Christie Iverson, 6. Selmer Myreboe, 7. Milton Brauer, 8. Professor Calvert, 9. Ole Fagerlie, 10. Norman Johnson, 11. Henry Iverson, 12. Sena Sundenau, 13. Louis Olson, 14, Norstad Nelson, 15. Fred Halstead, 16. Alfred Johnson, 17. Ronald Young, 18. Alma Young, 19. Edith Pitsenberger, 20. Emily Fosse, 21. Mabel Olson, and 22. Theodore Mattson.

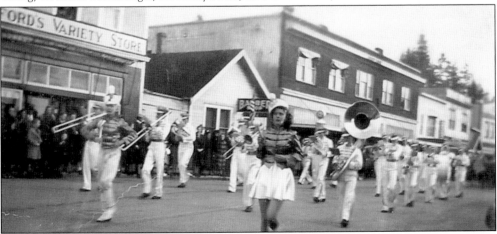

The 1938 North Kitsap High School Homecoming Parade passes the intersection of Front Street and today's Jensen Way, at that time known as Poulsbo Avenue. The Poulsbo Variety Store is in the Hostmark building. The small white Lofall Barber Shop was later moved up to Third Avenue for barber Chris Twedt. In its place, today's senior center was built as Lofall's Barber and Beauty Shops. (Courtesy of Oyen Collection.)

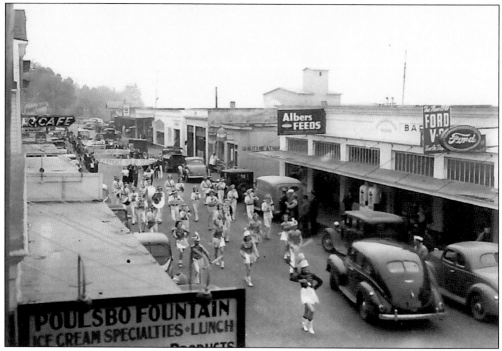

A view of the growth of Poulsbo after World War I can be seen in this photograph of the homecoming parade of 1939. The Poulsbo Fountain Café and Len's Café are on the left, while the Rindal and Ness feed mill tower can be seen above the stores on the right. Continuing to the right are Young's Garage, Reliable Hardware, Quality Meat Market, Borgen's Feed Store, and Bartlett Motors.

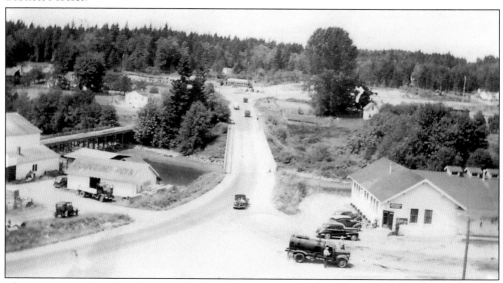

The entrance to Poulsbo from the head of the bay has traditionally been through this junction, commonly known as Irish's Corner for a tavern that used to stand here. The bridge on the left was the old wooden bridge. The bridge on the right opened in 1931. It was replaced in 1965 with a culvert that impeded salmon spawning. Today, a salmon-friendly bridge built in 2003 remains at this site.

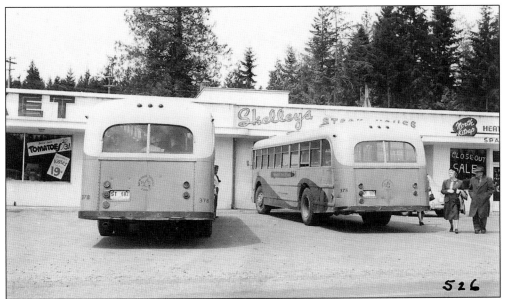

At the time of this photograph in 1947, the new shopping center on Highway 21 was in Poulsbo Junction, an unincorporated area. It included the I. and P. Market (for owners Ione and Pete Torgeson), Skelley's Restaurant, and Johnson's Electric Shop. The area was annexed to Poulsbo about 1973. Today Highway 21 is Viking Avenue. The shopping center was the bus stop for the commuter buses during World War II.

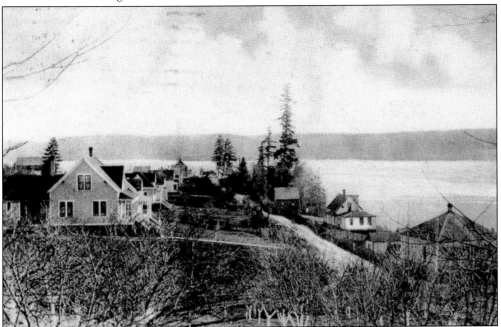

The oldest residential street in Poulsbo is named Fourth Street on its north end. On its south end, it is Fjord Drive, shown here about 1904. From earliest times the road along the water has also been called Beach Drive and Bayview. The homes seen in the foreground belonged to (left) Capt. Alfred Hostmark, (right rear) Ole Hegdahl, and (right) Nels Iversen. All of these homes are still standing.

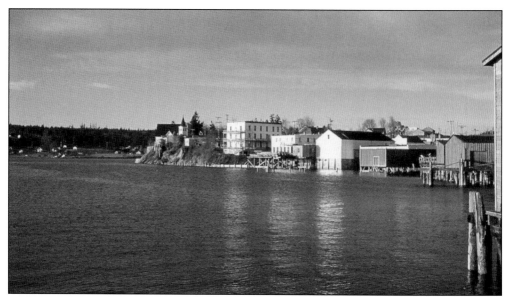

From the beginning, buildings on the water side of Front Street were built on piers out over the water, as seen in this 1951 photograph of Poulsbo's waterfront. With a business district squeezed between water on one side and a steep hill on the other, downtown became much too crowded when automobiles became an integral part of the landscape and required wider streets. (Courtesy of Ness Collection.)

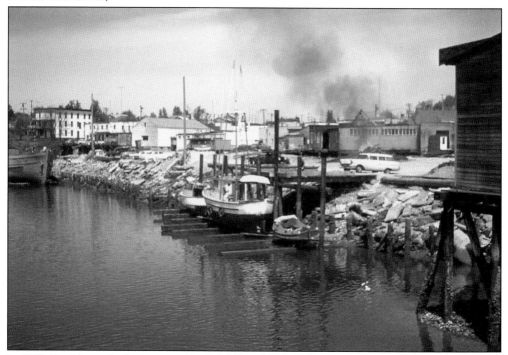

In 1952, Poulsbo embarked on a project to fill in the waterfront to create a parking mall. In this photograph, the work of filling is nearly complete. Scrap lumber left over from filling in behind stores and remodeling their backs to fit the new scheme is burned in preparation for covering the parking lot with its final course of gravel. (Courtesy of Ness Collection.)

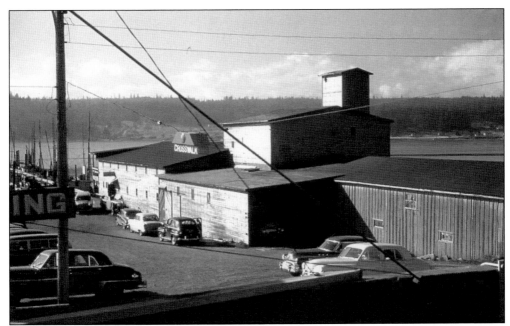

Ingenuity was necessary to make a driveway to connect two parking areas created when the fill was in place. The long warehouse of the Rindal and Ness Feed Store stood squarely in the way. Lucky for the town, the need of the feed mill for the warehouse shown here was waning. (Courtesy of Ness Collection.)

The answer was provided by the store itself, when it offered to tear down the feed mill and cut a 30-foot swath out of its building to give the city parking access. The two buildings still stand in Poulsbo, and the driveway was named Queen Sonja Vei in 1995 in honor of the visit of Norway's queen. (Courtesy of Ness Collection.)

Lemolo Shore Drive winds along the shore of Liberty Bay to the sleepy little community of Lemolo. Graceful Mount Rainier and the snow-capped Olympic Range overlook summer homes and small farms. Lemolo's earliest inhabitants were Suquamish tribal members. Place names reflect that heritage—Lemolo, Ne-Si-Ka, Kiana, and Tukwila. When the boundaries of the Port Madison Indian Reservation were set, Lemolo was exempt, making it ripe land for settlement.

Coming in 1888, the Frank Johnson family was among the first to settle in Lemolo. To distinguish his farm from other Johnsons, Frank named his Liberty Place. The name proved popular, and a few years later, Dogfish Bay lost its ugly moniker and was renamed Liberty Bay. Here, Liberty Place is seen from its eastern hill overlooking Liberty Bay with the Olympic Mountains on the horizon.

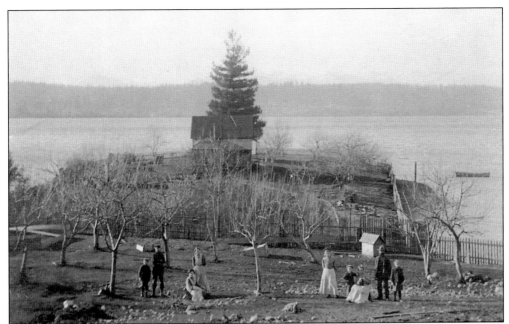

Rev. Uno N. Brauer, from Sweden, settled near the Johnsons on Brauer's Point in the late 1890s. The Brauers pose in their orchard about 1910. From left to right are Gordon, Milton, Ruth, Dorothy, Mildred, unidentified, Sarah, Uno, and unidentified. In 1907, the newspapers announced that a new steamboat landing named Lemolo would begin between Johnson's and Brauer's places.

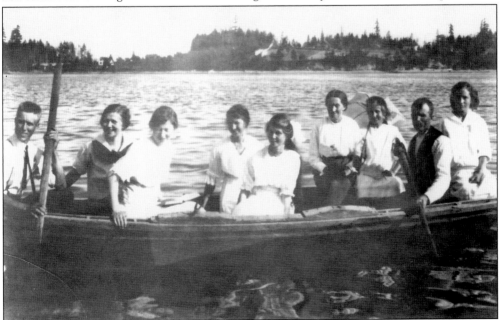

Longtime Lemolo inhabitants the John Seierstad family arrived in 1907 with six girls and one boy. Their tall farmhouse overlooking Liberty Bay still stands. The Seierstads were active in community and church activities, and rowing to church on a Sunday morning was not at all unusual for them. From left to right about 1913 are Oscar, Hilda, Gina, Mabel, Edna, Marie, Aleda, John, and Amanda.

The Lemolo steamboat landing abutted the property of Andrew Jacobson, who capitalized on its proximity and began a general store and post office near the dock. The Jacobsons gathered for a family photograph around 1910. From left to right are Maldor, Lillian, grandmother Bertha, Andrew, Freda, and her sister, Hilda Axlund. Notice the doghouse behind the home. The Jacobson, Seierstad, and Johnson homes still stand in Lemolo.

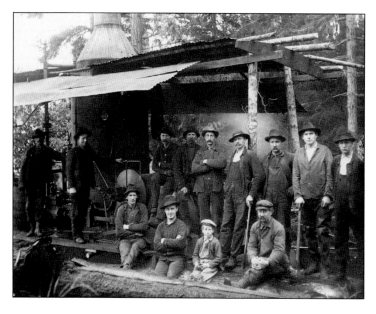

Lemolo was (and still is) heavily timbered, the perfect spot for a lumber mill. Gathered in front of their steam donkey, Lemolo lumbermen are, from left to right (first row) Godfrey Norman, Axel Beckstrom, and Ray and Frank Peterson; (second row) four unidentified, Otto Norman, Dave Noll, Anton Norum, Rick Norman, and Nels Erickson. (Courtesy of Snouwaert Collection.)

Narrow dirt roads were the rule in Lemolo until well into the 1940s. Today's Lemolo Shore Drive is still narrow and winding, but Hatta's Bridge, shown here around 1911, is now paved with protective guardrails over the foliage-filled gully. Posing on the bridge from left to right are Gladys and Laurence Norman with Ethel and Richard Peterson. (Courtesy of Snouwaert Collection.)

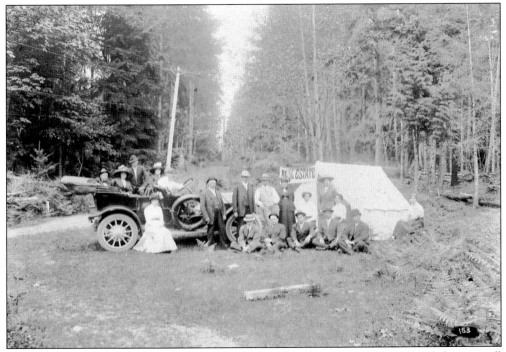

Early in the 1900s, a long, narrow tract of land along the bay in Lemolo was divided into small lots for summer homes. Here a group of Looky-Lous from Poulsbo, chauffeured by Ronald Young, visit the real estate tent for Lemolo Acres in 1915. Many business families from Seattle built summer cabins in Lemolo.

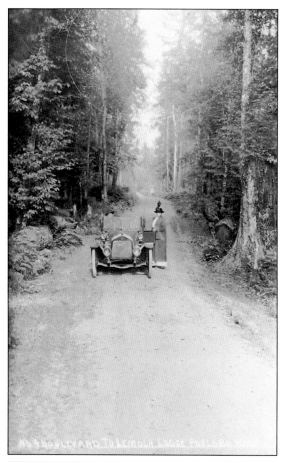

Mary H. Cross operated a summer resort known as Lemolo Lodge in the Lemolo Acres tract. She lodged boarders and rented out nearby cabins to summer guests. Mary Cross was actively involved in the Lemolo Improvement Club, Lemolo Red Cross, and a myriad of other civic organizations in Lemolo and Poulsbo. She stands near her automobile on the road to Lemolo Lodge around 1915.

The Lemolo Improvement Club formed in 1914 as an effort to provide a social center for the growing community, with the side benefit of providing a school for the area children. The building shown here was completed in the fall of 1915, the work of volunteer labor from Lemolo men, and a room for the school was outfitted within the building.

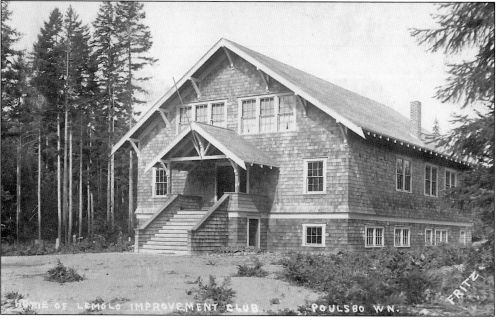

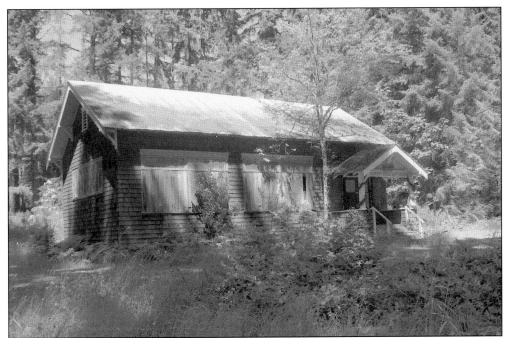

The Lemolo Hall served as the Lemolo School, an annex of the Poulsbo Elementary School, from 1915 until 1921. Then this small two-room schoolhouse was built near the hall and served about 27 children until Lemolo merged with Poulsbo Elementary School. For a time in the 1980s, the old school saw duty as a gift shop.

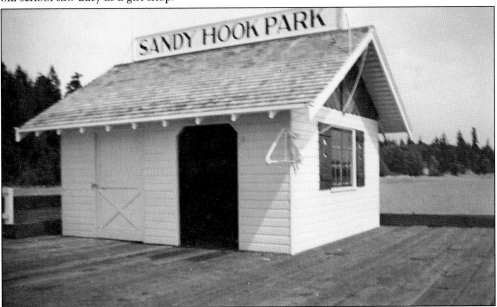

In 1935, a Seattle company promoted the Sandy Hook Resort development containing small vacation homes, a salt water swimming pool, and a public dock, shown here. The resort was popular with Seattle families wanting to escape the noise of the city during the summer months. A few families enjoyed their getaway so much they moved in full time, taking the steamer to work in Seattle.

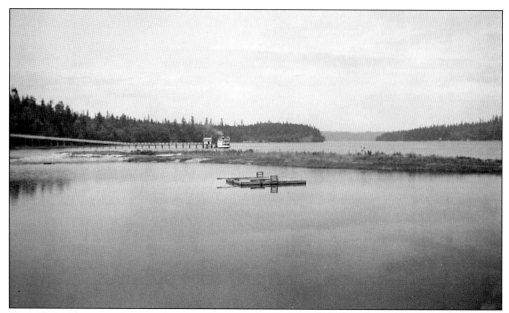

One of the big attractions at the resort was a salt-water pool. Officially, it would not have been called a swimming pool by today's standards. It was a swimming area sheltered from the main stream of Liberty Bay by a sand spit. The diving raft is seen in this photograph, and the steamer dock can be seen in the background.

Shown here are two of the small cabins at the Sandy Hook Resort with a family enjoying their stretch of beach. By 1939, the resort was renamed Edgewater Beach Resort. Still later, it closed for a time and reopened as Kiana Lodge. Kiana Lodge remains a destination place for banquets, weddings, and conferences. Today it is owned and operated by the Suquamish tribe.

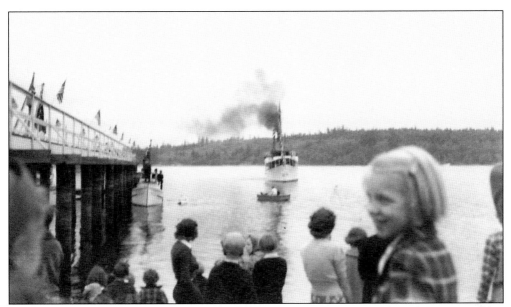

Royal visitors to Edgewater Beach Resort in 1939 were Crown Prince Olav of Norway and his wife, Princess Martha. On a three-hour tour of Puget Sound, the royal couple did not have time to come all the way to Poulsbo, so residents had to be content to greet the royal yacht at the resort. Here, little Norma Anderson waits to see the royals. (Courtesy of Hanson Collection.)

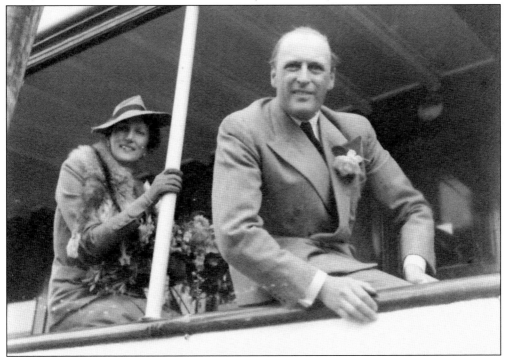

The stop at Edgewater Beach Resort was a brief one. Prince Olav did not leave his royal yacht, *Aguilo*, but did stop at the dock and wave a cheery hello. Princess Martha accepted a bouquet from the well-wishers, who were satisfied with a glimpse of the royal couple. In 1976, as King Olav, he returned to Poulsbo for a banquet at the Sons of Norway Hall. (Courtesy of Hanson Collection.)

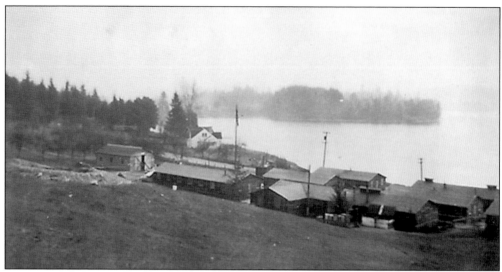

A stone's throw from the busy Keyport Naval Station, Lemolo has managed to retain its rural nature through two world wars, despite the basing of soldiers on its shores during World War II. This small Army base was established near the Johnson farm for soldiers overseeing the barrage balloons along the bay and maintaining the security of Agate Passage.

Following the war, the mess and recreation hall of the Army base, seen here in the background, became a community center and dance hall for Lemolo residents. Known variously as the House of Blue Lights or the Teen Canteen, the dance hall was a popular spot on Saturday nights. Shown in the foreground of this photograph are neighbors Charles and Paul Randall. (Courtesy of Charles Randall.)

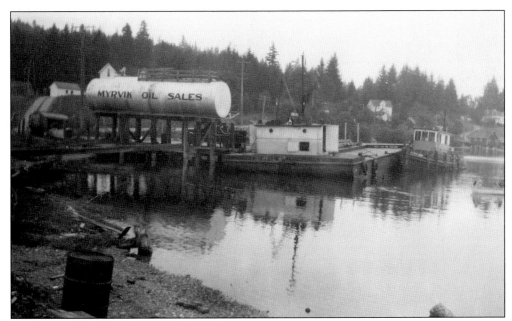

A mid-century business along the Lemolo shoreline was Myrvik's Oil Company, which delivered heating oil to many Poulsbo homes and businesses. Owned by Mel Myrvik, the oil dock filled the area once occupied by the Arneson Sawmill. Today, it is the intersection of Sixth Avenue and Lemolo Shore Drive near the Poulsbo Yacht Club.

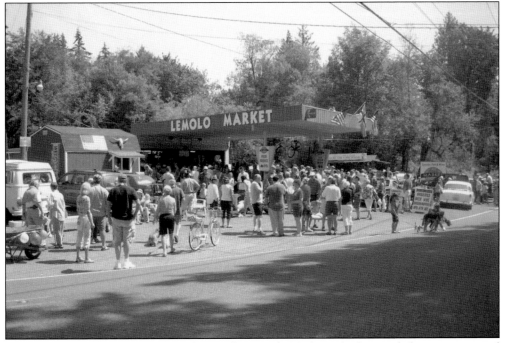

A second longtime business in Lemolo was the Lemolo Market, which provided a gas station and mini mart from 1950 until it closed at the end of 2009. It was a favorite candy stop for Lemolo kids and a general social center for morning coffee regulars. Opening in the 1930s in a building across the street, it closed for a time in 1942, when the war made supplies difficult to obtain.

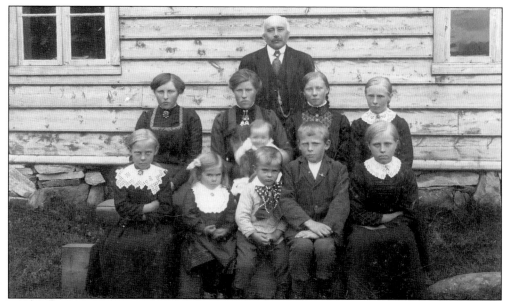

The Lincoln District stretches from Lincoln Road and Highway 305 in Poulsbo to the boundaries of the Port Madison Reservation. Area homesteaders were known mostly for poultry and dairy farms, strawberry fields, and an occasional sawmill. In the mid-1890s, Lincoln's one-room school did double duty as a Sunday school led by Nels Olson, a layman from Fordefjord Lutheran, who taught Bible to several children on Sunday afternoons.

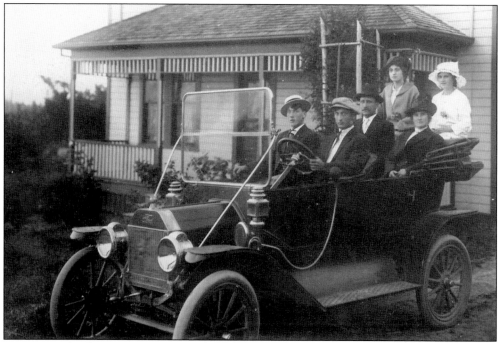

The Martin Hoff family, shown here in 1913 (from left to right are Clarence, Alfred, Martin, Helga, Wanda, and Alice), prepare to leave their Stottlemeyer Road home in their 1912 Ford. Among the earliest settlers on the hill, the Hoffs emigrated from Norway, taking out a homestead in the Lincoln District in 1888. (Courtesy of Hoff-Goode Collection.)

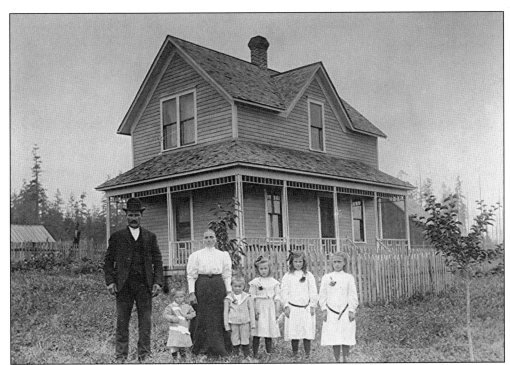

Jorgen and Jensine Sommerseth emigrated from Norway in 1904 and settled on Lincoln Hill, where they farmed. The family is shown here in the front yard of their farm house in 1907. From left to right are Jorgen, Peter, Jensine, Hickman (nicknamed "Hickey"), Dorothy, Anna, and Mathilda. A third son, Julius, was born later that year. (Courtesy of Arnetta Cheatham.)

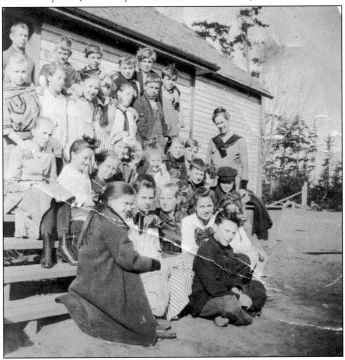

The first Lincoln School, shown in this photograph, burned in 1931. That same summer, the old school in Poulsbo was torn down, so lumber salvaged from that building was used to build the new Lincoln School. The children of Lincoln School gathered for a photograph on the steps of their two-room school in 1918. Unfortunately, the identities of the students and teacher remain a mystery.

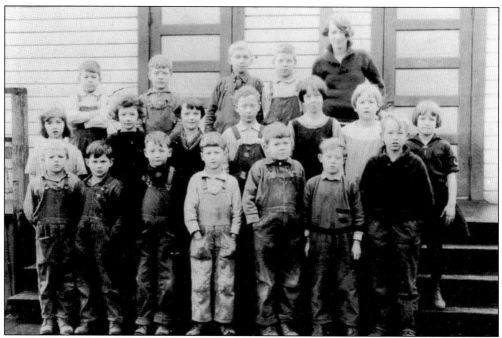

Grades one through four at Lincoln School were photographed in 1923. From left to right are (first row) Gurvis Alness, Leo Weberg, unidentified, Earl Williams, Boyd Winter, Iver Bjorgen, and Oscar Eliason; (second row) Margaret Moore, Annie Wallace, Evelyn Wright, Irvin Bjorgen, Alice Bjorgen, Edna Peterson, and Esther Lund; (third row) Arnold Winter, Burton Blair, Harold Jacobson, Fenton Moore, and teacher Olga Teien.

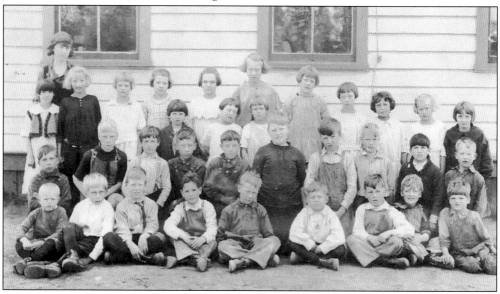

A year later, in 1924, Lincoln School students posed outside for the annual rite of school pictures while their comrades in the other class peeped out the window. Many of the same families are represented—Peterson, Wright, Lund, Bjorgen, Alness, and Winter. A few new names have been added, Stottlemyer, Soli, and Remberg among them, reflecting the growing population of the area following World War I.

In 1931, after the fire, this new building was constructed. It served as the school and community center until World War II, when Lincoln-area children were bused to Poulsbo for school. At that time, the school building became the Lincoln Grange Hall, with classrooms giving way to a dance hall and central meeting venue for local clubs.

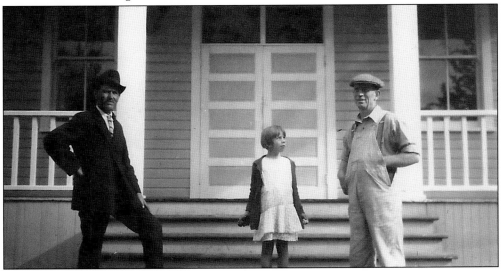

Little June Virkelyst listens intently to her father while they pause in front of the new Lincoln Grade School about 1932. Nels Virkelyst was a Danish dairyman of excellent repute. His Poulsbo Dairy in the Lincoln District specialized in quality buttermilk. Characterized by the local paper as the "Cream of the Cream," his twice-a-day deliveries of bottled milk, cream, and buttermilk kept his dairy humming. (Courtesy of June Breiland.)

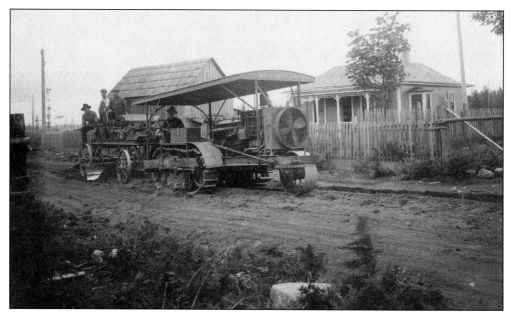

The first motorized road equipment owned by Kitsap County was this caterpillar tractor used for grading local roads. From left to right, county commissioner A.J. Shold, unidentified, and county road supervisor Erik Olson accompany driver Ole A. Olson aboard the caterpillar in the Lincoln District about 1912. Erik was a long-term road supervisor for the county.

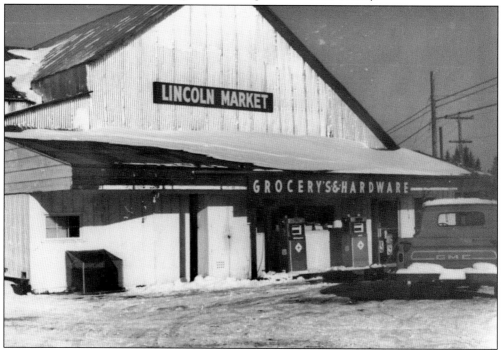

Businesses were not common on Lincoln Hill, but remembered by many still living is the Lincoln Market, which carried groceries, hardware, and the essential gas pumps. It seems strange to the modern safety consciousness to see the pumps tucked up so close to the front wall of the store. Perhaps this practice was a contributor to the raging fire that destroyed the market in the 1970s.

Big Valley (Gudbrandsdalen in Norwegian), immediately north of Poulsbo, was an early settlement area. Its position near the head of the bay made for easy access for loggers needing to float out their logs. Perhaps the earliest settlers here in the mid-1880s were logger-farmers Stener Thorsen (shown with wife Ragnhild) and his brothers, Iver and Ole Thompson. (Courtesy of Denise Bailey.)

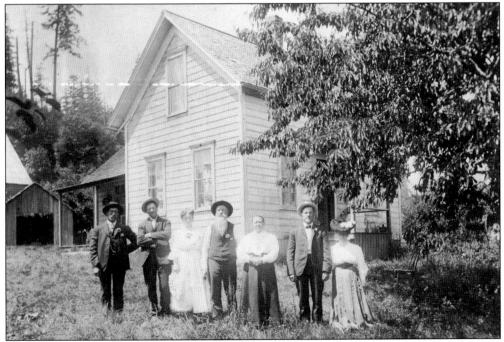

After the wedding of Oscar Ryan and Ruth Ferris in 1913, the wedding party gathered in the yard of the Stener Thorsen home. From left to right are Oscar Ryan, Ole S. Olson, Ruth Ferris (granddaughter of Ole Thompson), Stener and Ragnhild Thorsen (aunt and uncle of the bride), and an unidentified couple. The house was typical of homes in the valley. (Courtesy of Iras Ryan.)

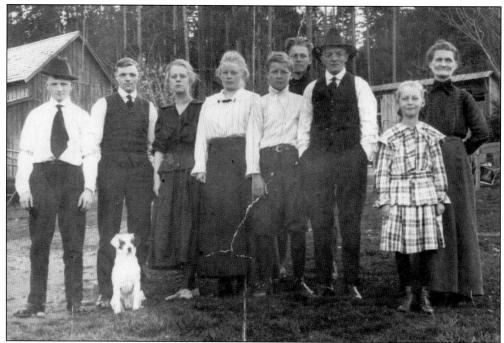

Early settlers in Big Valley included the Andrew Fredericksen family, arriving in 1890. Descendants of this large family still live in the valley on land their ancestors homesteaded. Like most homesteaders, the Fredericksens worked as both loggers and farmers; the trees had to be removed before the land could be tilled. Shown from left to right are Matthew, Olaf, Clara, Marie, Alvin, Conrad, Fred, Alma, and mother Ragnild. (Courtesy of Fredericksen Collection.)

The large log Fredericksen barn was a landmark in Big Valley for over 100 years. Built of cedar logs set on cedar stumps, all culled from the Fredericksen property, the structure contained no nails. According to the family, it was built with block, tackle, and one horse, along with a generous supply of manpower. The aged barn, becoming a safety hazard, was razed in August 1996.

The Swedish-born John Bergman family moved to Big Valley shortly after the turn of the century. His wife, Margaret Bergman, an accomplished weaver, soon became known for her fine work. Margaret was in need of a folding loom to use in teaching weaving classes, and John Bergman went to work developing one. In 1932, the loom, shown here with Margaret at work, was fully developed and ready for market.

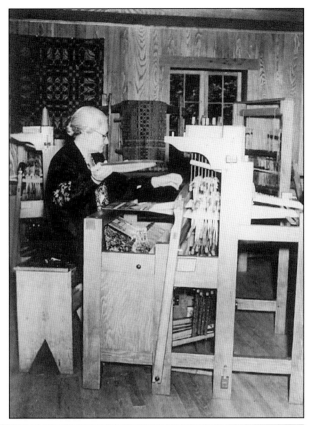

The Bergman barn was turned into a classroom and loom shop, as well as a yarn and craft supply store known as the Yarn Barn. It remained in business until well into the 1980s, keeping area knitters, needle workers, and weavers well supplied with yarn. Today, the Yarn Barn is seeing duty as a restaurant, Molly Ward Gardens.

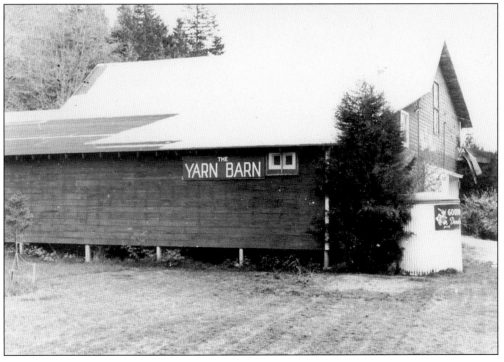

Children who lived mid-valley had a long walk to school, going either to Breidablik School, near the west end of the valley, or to Poulsbo, a mile from the east end. The Franklyn School, shown here with windows open and curtains flying, opened in 1910. It continued until it was consolidated into the North Kitsap School District in 1939. The old building is now a private residence.

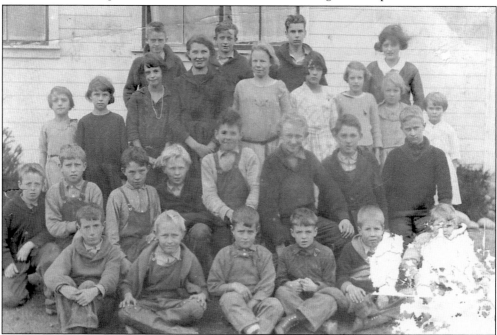

Franklyn students in 1923 are, from left to right, (front row) Harold Kleivan, Willie Hahto, Howard Kvinsland, John McGinty, Olof Hilton, and Orren Kvinsland; (second row) Carl Kleivan, Stener Kvinsland, Eino Hahto, Emil Ravet, Philip Kvinsland, Toivo Hahto, Fred Johnson, and Anton Frederickson; (third row) Gladys Johnson, Adeline Ravet, Ellen Frederickson, Philomena Ravet, Clara Hilton, Jenny Johnson, Ruth Smith, Martha Hilton, and Edith Foss; (fourth row) Melvin Frederickson, Conrad Kleivan, and Arden Smith.

Harding School served children in the east end of the valley and west of Liberty Bay. It was built near the county sheds on Bond Road in 1922 and closed in 1944. The building was then relocated to Irish's Corner, becoming a wing of the Triple M Dairy. The teachers in this 1936–1937 photograph are Olga Hugo, top, and Alice Vaa, right.

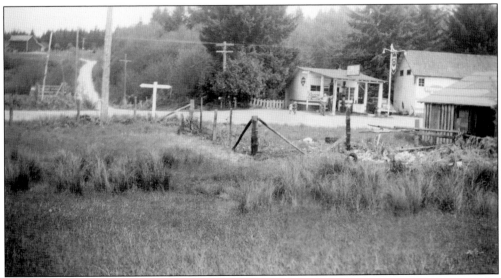

Across the intersection a short distance from the Harding School at Vincent's Corner was the Harding Store, a gas station and mini-mart in today's terms. Owned by mechanic Frank Vincent, it offered full-service repair for automobiles, Standard Oil brand gas and oil, small groceries, and sundries. Vincent died in 1952, and the station closed. Today, a dental clinic stands at this busy intersection.

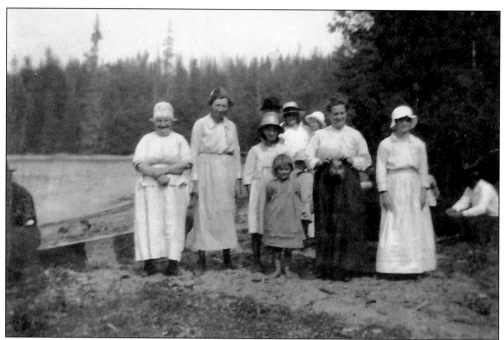

The women of Big Valley often gathered for social events, picnics, prayer groups, and ladies' aid. Most of them were related through marriage in some way, so social events were more like family gatherings. Identified here from left to right are Hilma Foss, Emma Grondahl, several unidentified children and women, and Mary Fredericksen (in the dark skirt).

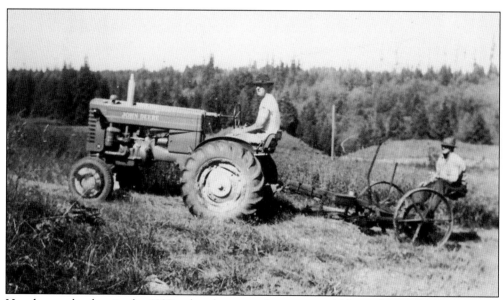

How happy the days in the 1930s when horses and wagons could be exchanged for a new John Deere. The Thorsen farm laborers enjoyed the convenience of haying their hilly farmland from the seat of the tractor, a comfort unknown to their grandfathers. Big Valley today remains rural farmland, nearly untouched by commercial development. (Courtesy of Denise Bailey.)

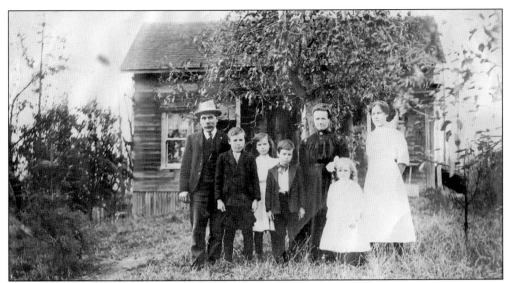

Breidablik stretches from the Hood Canal Bridge south to Pioneer Hill. Norwegian for "broad, gleaming" or loosely translated "heaven," it seemed an apt name to settlers with broad, magnificent views of Hood Canal and the Olympic Mountains. An early family was the Paulsons. Knut and Sigrid Paulson raised five children. From left to right around 1914 are Knut, Paul, Tilda, Ole, Sigrid, Martha, and Inga in front of their Breidablik home.

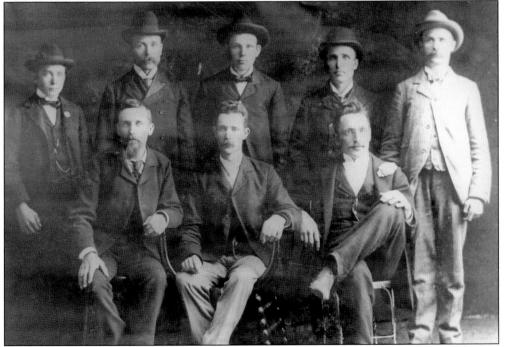

Early pioneers of Breidablik gathered for this photograph about 1910. From left to right are (first row) Olaf Wistrand, John Molander, and Paul Paulson; (second row) Jacob Shold, Gilbert Paulson, George Shold, Henry Paulson, and Erik Bergman. Paul and Gilbert Paulson were brothers of Knut Paulson. Breidablik was known for its dairy farms, and most of these men were dairy farmers and part-time loggers.

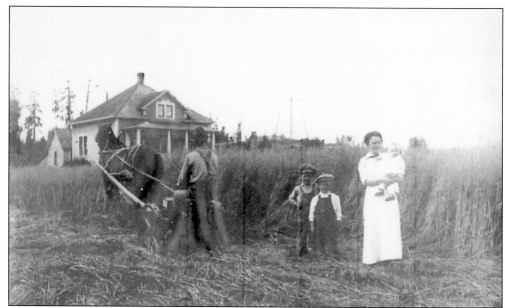

Edwin and Ida Vaa were another Breidablik family who lived on Waghorn Road. Edwin was busy haying with his team the day Ida and children Lawrence, Wendell, and Vivian posed for the photographer in 1915. Ida was a school teacher before her marriage to Edwin. Normally, married women did not teach school. However, World War I pulled Ida back into service for several years. (Courtesy of Wallin Collection.)

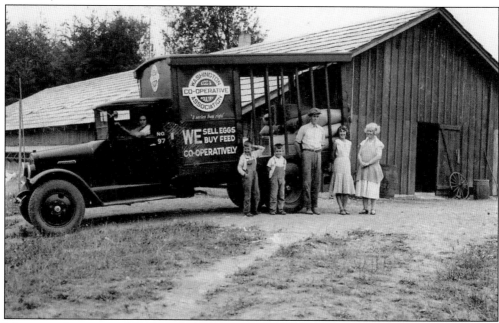

Many years later, around 1930, some of the Vaa family posed with a different kind of horsepower. The driver of the Washington Cooperative Association delivery truck remains unidentified but might be Nick Johnson, the father of Jimmy and Agnes Johnson. Others from left to right are Bob Vaa, Jimmy Johnson, Lawrence Vaa, Agnes Johnson, and Bob's mother, Ida Vaa. (Courtesy of Wallin Collection.)

The first area school began in the home of Nels Hanson on Sawdust Hill in Big Valley. A year later, a schoolhouse in Breidablik was built on property donated by Gilbert Paulson. That 22-by-32-foot building (partially seen in this 1950s photograph) was a one-room school opening in the fall of 1894. When a new building opened in 1904, this became the Modern Woodmen of America Hall.

A two-room, two-story building opened in 1904 near the old Breidablik School. Baseball was the favorite pastime on the school grounds. Perhaps owing to their love of baseball, even the girls were allowed to wear pants to school, an unusual move for the times. The two-room building remained in use until 1942, when students were bused to Poulsbo.

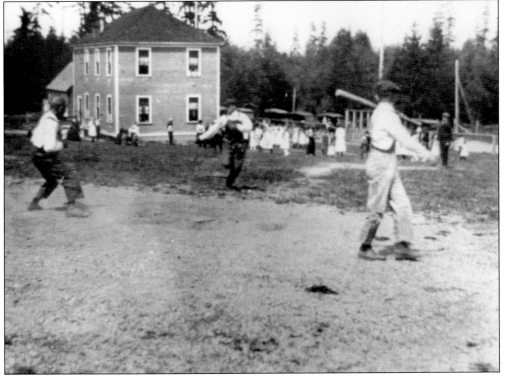

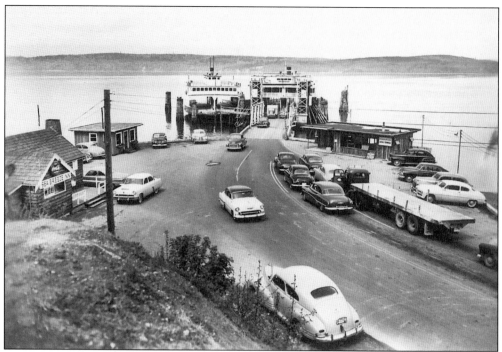

The large Helge Lofall family settled at the foot of the ridge in Breidablik in 1909. On early plat maps, it is named Lofall City; however, it was never incorporated as a city. Helge served as the postmaster for the mail delivered by steamer to his dock. In later years, a dock a short way north served as the landing for the Lofall-Southpoint ferry shown here.

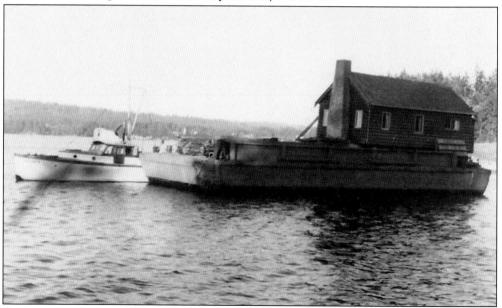

The Sea Breeze Inn is seen here as it was barged to Lofall in the 1950s. It refreshed ferry passengers for several years before the new Hood Canal Bridge to the north brought an end to the ferry in 1961. It opened again for a short time in the early 1980s, when part of the bridge collapsed in a storm and ferry service resumed until the bridge was rebuilt.

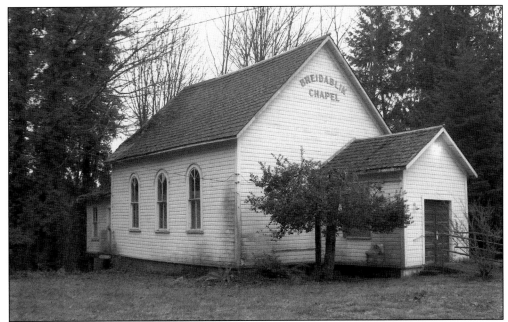

In July 1908, Hans Andersen donated one acre of land for the building of a Lutheran mission house at Breidablik. Six families joined in collecting funds for the building. By 1912, the chapel was in place, and the pastor from the Lutheran Free Church in Poulsbo came on a part-time basis for services. There is a small cemetery north of the chapel.

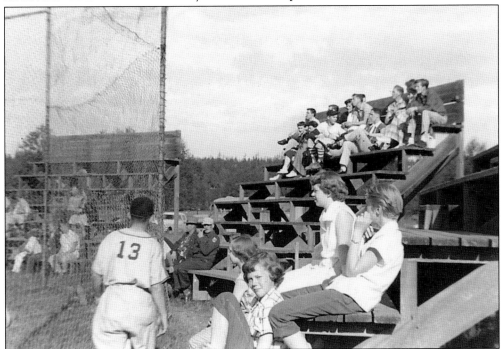

Today's Kitsap Memorial State Park began in the 1930s as a county park north of the Lofall ferry dock. The park was the site of the Lofall baseball field, shown here with its wooden grandstands. High school baseball games were played here until the ball fields in town opened in the 1960s.

The 80-foot-long log hall pictured behind these Lofall pioneers was a Works Progress Administration project built in 1935 shortly before the park opened. It still remains in the park and is used for picnics, dances, meetings, and weddings. Henry Brown, in the white hat (center), was the prime mover for establishing the park. This photograph is from a Pioneer Picnic held in 1971.

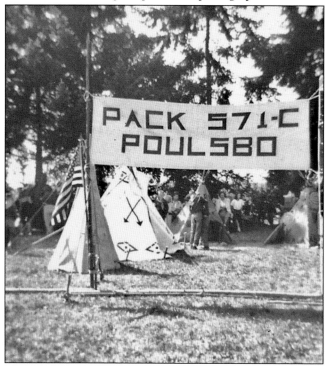

Kitsap Memorial State Park has been a popular venue for campouts like this District Boy Scout Pow-Wow, held in 1951. Here the boys of Pack 571, sponsored by First Lutheran Church in Poulsbo, demonstrate their tenting skills. Many North Kitsap youngsters trace their scouting years to Pack 571 (later known as 1571) and hold fond memories of campouts, pow-wows, and outings at the park.

Two old businesses have homes in Breidablik. Today's Four Corners Tavern opened in 1926 as a grocery and gas station on the Port Gamble road. In 1933, when Prohibition ended and Highway 21 opened, the building was turned to face the new road, and a tavern was added. According to one local, Four Corners was the only place she could buy a loaf of bread. (Courtesy of Steve Skelley.)

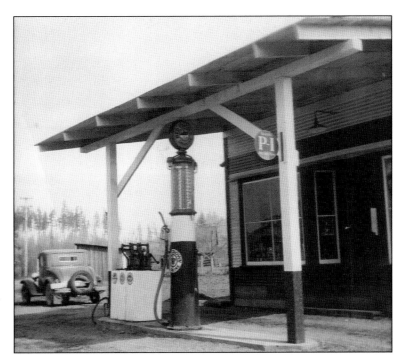

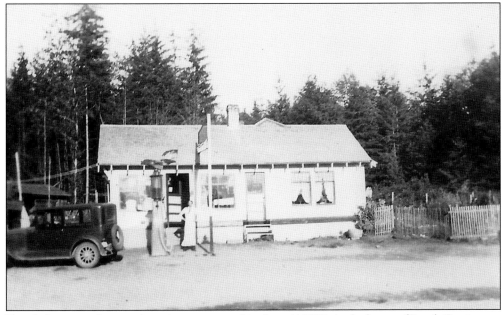

Frenchy's gas, sundries, and candy store opened in the mid-1930s in the home of Frank Carriere on top of the ridge. Following his death in 1941, it was run by his son, Frank Jr., who added a dance floor. Renamed often, it has been Roosevelt, the Lofall Inn, Hilltop Tavern, Bake's Spaghetti House, and several name-brand mini-marts. Hilltop is now a cement block building. (Courtesy of Camille Meyers.)

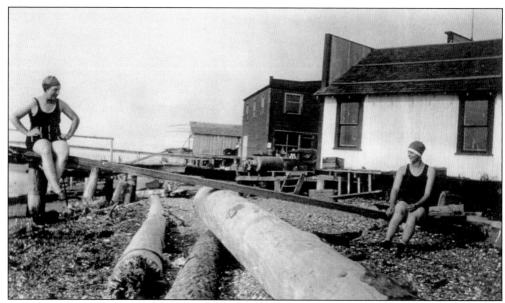

Vinland is the area between Breidablik and Bangor. The small village of Vinland sat within the confines of today's Bangor submarine base. Settled first by the Garthe, Svenson, Oen, and Lakeness families about 1890, it was home to farmers, loggers, and fishermen. Pictured around 1930 are the Oen sawmill (left), Oen hardware store (center), and Garthe's general store (right). The beauties are Evelyn McDonald (left) and Edna Oen.

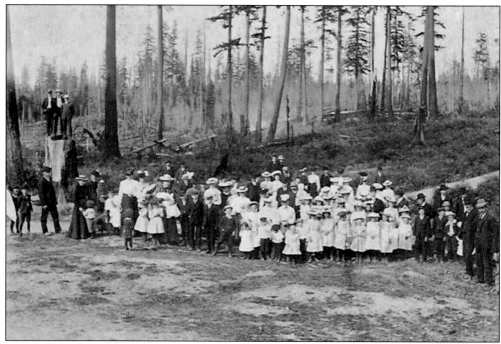

This early gathering of Vinland Lutheran Church, probably at the site of their future church and school, is a good picture of the kinds of problems these early settlers faced. This site has had its first cutting of old-growth timber, but the problems of stumps, undergrowth, and remaining trees all had to be surmounted before the land was habitable for home and farm.

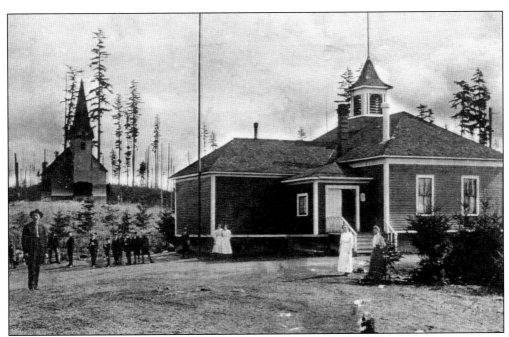

The Vinland School opened in 1893. Before that, classes were held in Haldor Myreboe's home. Lumber for the school was hauled from Poulsbo on the backs of sturdy Vinland men Halvor Svenson and Christ Lakeness, since roads to Poulsbo were not in existence at that time. Built in 1912, Vinland Lutheran Church sits on the hill behind the school.

Vinland Lutheran Church formed about 1892 as a mission congregation sharing a pastor with Fordefjord Lutheran Church in Poulsbo and a congregation in Bangor. Services were held in the school until the church was built in 1912. A terrific blaze consumed the building in 1960. The following year, on the same site, the congregation built a modern structure that stands today, surrounded by the graves of Vinland's pioneers.

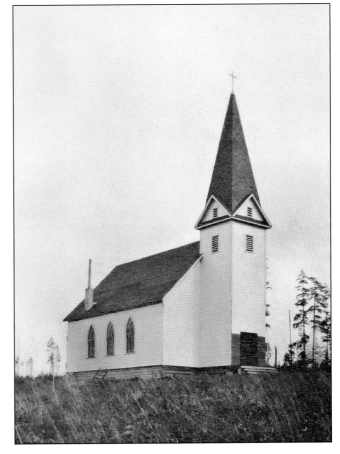

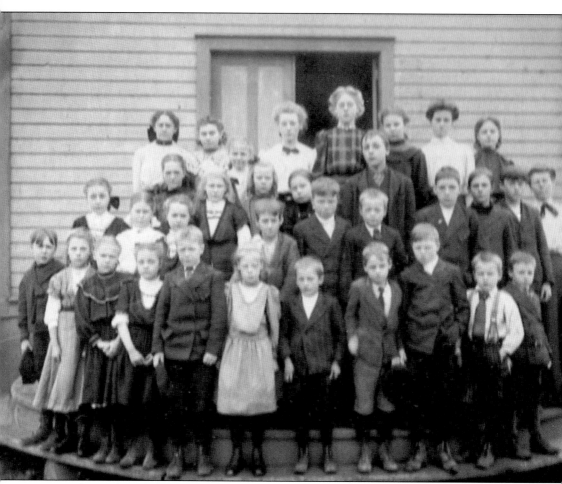

Students of Vinland School stand on their curved front steps in 1908 for a photograph. From left to right are (first row) Adolph Schey, Alma Norlander, Bertha Birkeland, Alice Oen, Martin Martinson, Beolina Martinson, William Brown, Melvin Swenson, Aman Sandvik, Hjalmar Brown, and Paul Paulson; (second row) ? Martinson, Henry Myren, Alfred Garthe, and Anna Murley (teacher); (third row) Valborg Rokstad, Lydia Norlander, Louise Halvorson, Inga Paulson, and Norman Oen; (fourth row) Lena Vetter, Hilda Svenson, Borghild Birkeland, Rosella Lovos, Inga Brekke, Inga Dybsetter, Clara Svenson, and Jenny Brown. Teacher Anna Murley was a niece of Haldor S. Myreboe.

Birthdays were common for Marit Garthe Svenson. Not only did she celebrate nearly 90 of her own, she was also the midwife for countless mothers in the Vinland district. Her family remembers that late into her years she was often called on to witness delayed birth records for babies she had delivered. She was the matriarch for an extensive family that touched nearly every family in the Vinland area.

At the beginning of the 20th century, brass bands were the rage. Vinland had its own band under the direction of Mike Berger. Members shown here, but not identified in order, are leader Mike Berger, John Garthe, Ted Garthe, Albert Garthe, Louie Vaa, Albert Vaa, Henry Brown, Helmer Oen, Adolph Oen, Norman Oen, ? Matson, Halvor Veggen, an unidentified drummer, Leonard Munsch, Anton Dov, and Ed Lakeness.

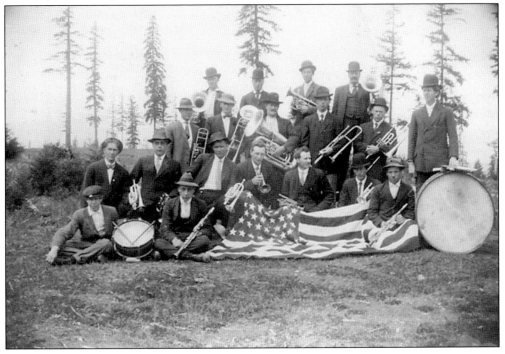

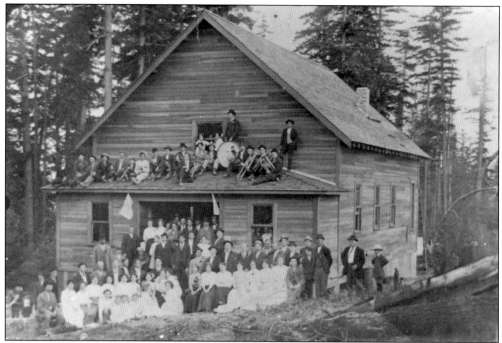

The North Star Hall, commonly referred to as Finn Hall, was a community social hall on Finn Hill between Vinland and Poulsbo. Saturday night dances, at which local musicians played, were common and enjoyed by everyone. Shown here in an unexplained pose on the roof of the hall is the Vinland Band. In 1930, the hall burned to the ground, moving weekend dances back to local barns.

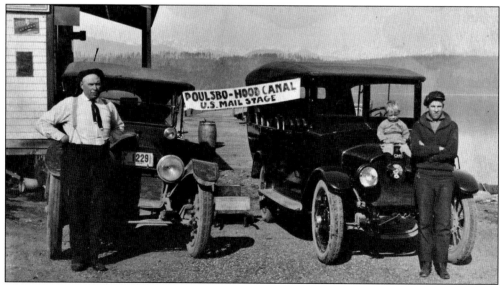

Starting in 1918, Nels Sonju (left), a Poulsbo hotel owner, operated the Vinland-Poulsbo mail and stage line. Shown here in 1919, he waits at the Vinland dock with his son, Howard, and grandson Robert. Sonju brought the mail from the steamer in Poulsbo to the Vinland Post Office and picked up passengers, freight, and mail needing to go to Poulsbo. The GMC vehicle driven by Howard (right) seated 16 people.

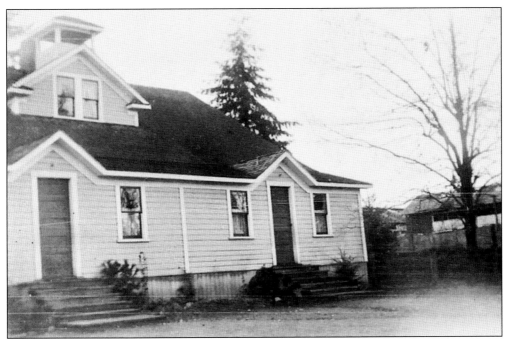

A second school served the Vinland-Bangor area, the Pleasant Ridge School, shown here in the 1930s. In 1906, the small Sunnyside School west of Poulsbo closed, and a school was built at the top of Sherman Hill. That school was Pleasant Ridge. Pleasant Ridge School closed in 1944, when families were displaced by the government buildup of the Bangor naval base.

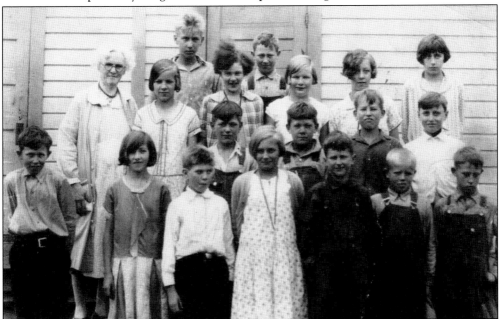

The children of Pleasant Ridge School gathered with their teacher on the steps of their school about 1930. Unfortunately, the names of the students and their teacher are lost. Like many other rural schools, the Pleasant Ridge School was also used for church services, an occasional funeral, and community gatherings of all kinds. Rural schools were the social center of their communities.

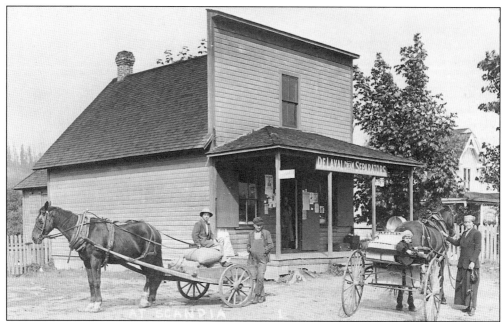

Scandia is a farming community across Liberty Bay from Poulsbo. Among the earliest settlers at Scandia was the Frykholm family. John Frykholm settled on farmland on the west shore of Liberty Bay. In 1905, he built a store and dock. Nellie (the horse on the right) waits patiently outside the store for Aina Rissanen to climb into the buggy for the trip home. Aina's daughter, Aili, sits in the back.

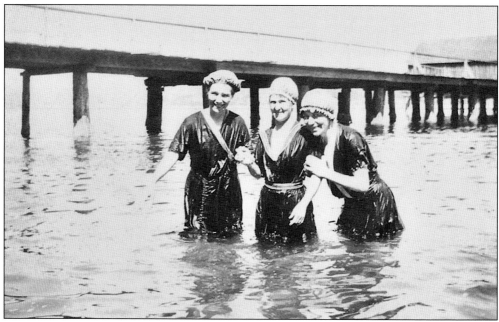

The three Frykholm sisters, from left to right, Lorraine, Donna, and Shirley, take to the water near the Scandia dock in this 1940s photograph. Water was a second playground for the people of Scandia, which is sandwiched between Highway 3 and Liberty Bay. Water was their highway, their grocery store, their playground, and their swimming pool. (Courtesy of Shirley Boehme.)

At an earlier time, around 1910, this well-dressed party was out for a Sunday row on the bay. The tangle of trees behind them shows how untamed the land around Scandia was at that time. From left to right are Gunder Frykholm, Myrtle Cornell, Edna Cornell, Hilda Johnson, unidentified, Frank Erickson, Eva Cornell, Ed Pearson, and Carl Lundquist. (Courtesy of Shirley Boehme.)

The Scandia community enjoyed socializing. Being somewhat cut off from Poulsbo, they made their fun where and when they could. Here, with sandwiches in hand, the photographer called "Bite" instead of "Cheese" to coordinate their pose. The man at the top is Andrew Johnson. Mary and John Frykholm stand on the right. The only other identified person is the boy at left front, Maldor Lundquist. (Courtesy of Shirley Boehme.)

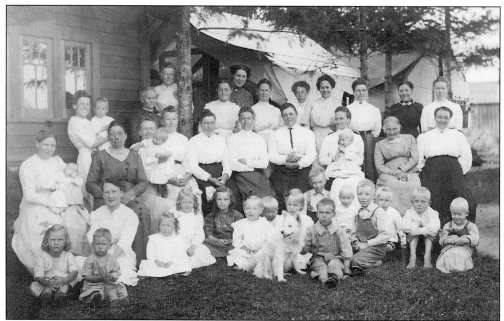

Women and children gathered at Scandia for this 1920s photograph. Grandma Anna Frykholm sits second from right in the second row. These may be the women of the Scandia Pearson Mission Circle, who planned money-making events to fund their church mission projects. They were not of one denomination but all worked together for success. (Courtesy of Shirley Boehme.)

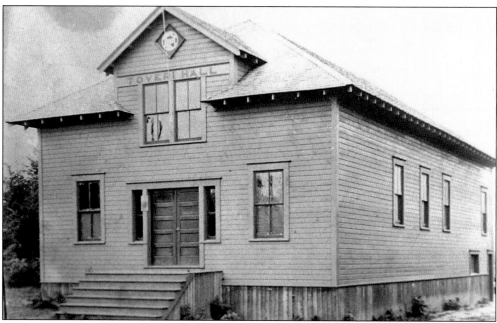

Toveri Hall, opened in 1910, was the social center for Scandia with its large Finnish population, and where there are Finns, there is music. The hall was the venue for dances, recitals, socials, and card games, but central to all was music. Irma Saula Harsila, who played the accordion and fiddle by ear as soon as she could walk or hold one, was often center-stage there.

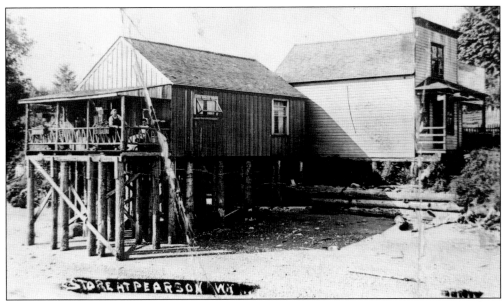

A short distance south of Scandia was the Pearson dock and general store owned by brothers Andrew and John Lundquist. In 1904, a cooperative store owned by farmers of Scandia and Pearson started in the Lundquist warehouse on the wharf. The Lundquists sold out to the Frykholms in 1905. In contrast to the Scandia store, the Pearson store sat directly on the bank of the bay.

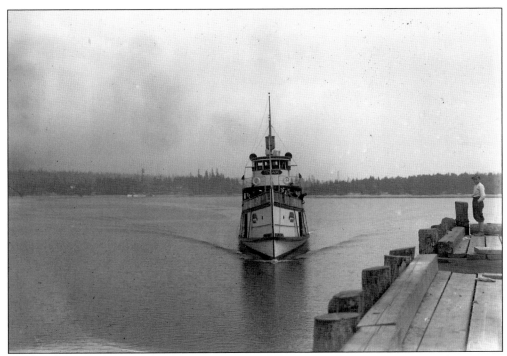

The steamer *Hyak* is shown docking at Pearson on August 2, 1919. In the distance, the steamer *Liberty* is docked at Lemolo. The closeness of Lemolo to Pearson made it possible for some residents of Lemolo to boat across the bay to Pearson for church services at the Swedish Baptist church in Pearson. (Courtesy of Joe Leaf.)

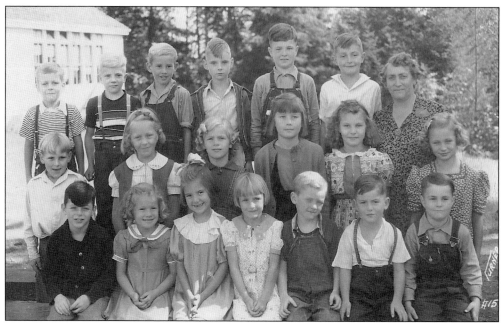

Pearson is named for Per John Person, who settled here in 1885 and applied for a post office in 1887. The application returned with the name Pearson attached; the postal supervisor said he liked it better. Eventually, the family adopted the Pearson spelling. Hilder Pearson, Per's daughter and a beloved teacher, is shown here with her third-grade class in 1938 at Keyport. Hilder Pearson School is named for her.

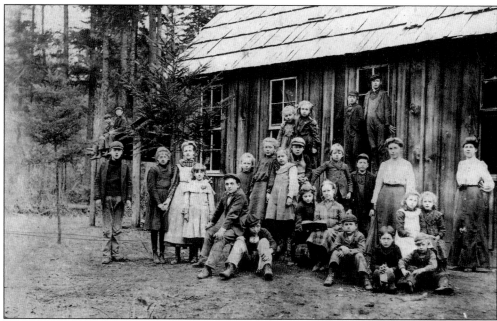

Pearson, Scandia, and Keyport are intertwined. In early censuses, they are all called Pearson. This photograph of the earliest known Keyport School was probably taken in the mid-1890s. The names of the teachers and children have been lost to time, but the spirit of those early students, who would even climb a tree to be photographed, remains.

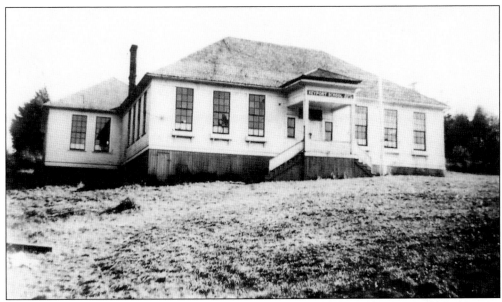

This is the third Keyport School about 1937 in a photograph taken by 10-year-old Juel Lange. There were three known Keyport School buildings at various places in the Keyport-Pearson area. This building, constructed in 1908, was dismantled in 1949 and moved to Viking Way in Poulsbo. It was rebuilt as North Kitsap Baptist Church and became Campana's Restaurant in the 1980s.

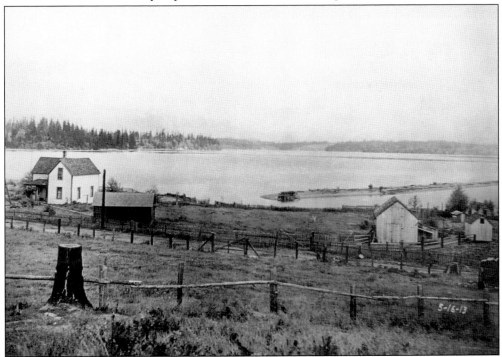

Keyport was a rural farm area, as can be seen in this 1913 photograph. The only activity other than farming was in the oyster beds lining the shoreline. Oyster farming does not require much land, and the state experimental station set up to explore oyster farming was quiet. Here the Paul Thompson farm overlooks the quiet north lagoon.

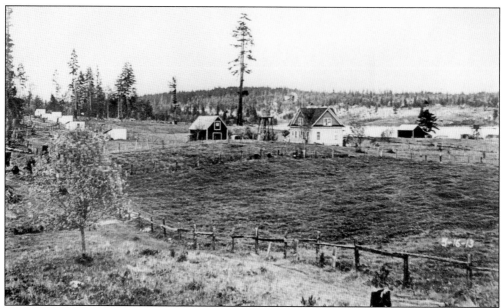

All that changed in 1910, when the federal government decided that Keyport would make an excellent torpedo base. Land was surveyed, and farmers waited warily for the verdict. When it came, five families, the Hagens, Husbys, Norums, Pettersons, and Thompsons, were paid $60,800 to split among them for their farmland. They had to relocate by 1913. Shown here is the Anton Norum home, which became the commander's "cottage."

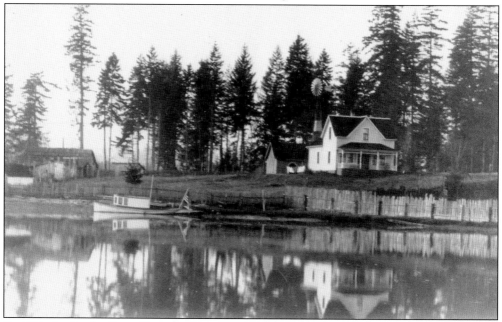

By 1914, the Pacific Coast Torpedo Base was established. Quiet farmland like this belonging to Alfred Petterson was transformed into a busy naval base. The Petterson home was moved and became Quarters B. Today, once rural Keyport is the Naval Undersea Warfare Center Division, Keyport. A tiny community huddled on the northwest shore of the peninsula is the only trace of former days. (Courtesy of Ruth Peterson Reese.)

Four

CELEBRATION
OUR JOY

Poulsbo enjoys celebrating. On May 30, 1891, Poulsbo welcomed visitors from around the sound for the dedication of the Martha and Mary Children's Home. It was the beginning of a tradition that has continued in one form or another yearly since that time. Home Day, shown here in 1912, brought 3,000 people to the home to enjoy food, music, dancing, and games.

Home Day in Poulsbo was a dressy event. As soon as the steamers began arriving, the streets were filled with hatted women, bowed and pigtailed girls, derby-wearing and dress-suited men, and straw-hatted and knickered boys. Steamers arrived at the docks in the south end of town. The crowds walked four blocks to the home on the north end of Front Street where the day's festivities took place.

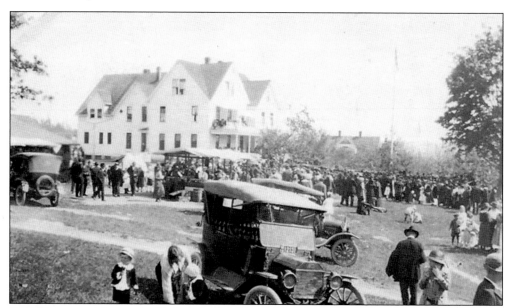

By 1920, automobiles were added to the mix, but little else had changed. Food was dished up at the covered booths in the center of the lawn. Generally, the day's agenda included welcoming prayers and speeches by town dignitaries, musical numbers and recitations by the children, then food, fun, and frolic (including games) until late afternoon, when the steamer whistles signaled the return trip to points around Puget Sound.

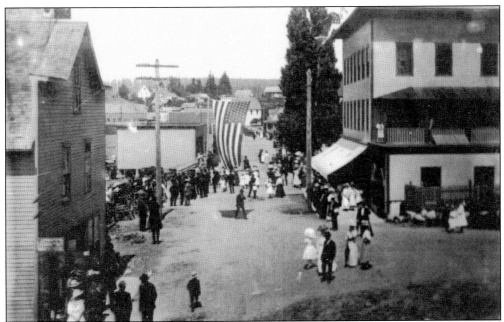

Next to Home Day, the biggest event was Independence Day on July 4. Poulsbo's immigrants happily celebrated their new citizenship right from the beginning. In 1909, the large flag of Mayor Andrew Moe billowed in the breeze on Front Street as the crowds began to gather. The building on the left is the Kitsap County Cooperative, and the one on the right is Eliason's General Merchandise and Post Office.

Races for all ages were a main feature of Independence Day. Here some well-dressed businessmen have doffed their suit jackets for the old man's race. The racers are unidentified, but Poulsbo's hardworking men were athletically inclined at any age. On the left are H.S. Myreboe's General Merchandise Store, the Millinery and Tailor Shop building, and the Olympic Hotel Annex building. Beyond the tree is the Eliason building.

This 1913 three-legged race featured Chris Twedt (left) and Fred Frederickson, two of Poulsbo's stalwart baseball players. Either these two are way ahead of their competition, or they are bringing up the rear, as no other contenders are in sight. Independence Day usually featured a baseball game between Poulsbo and a nearby community.

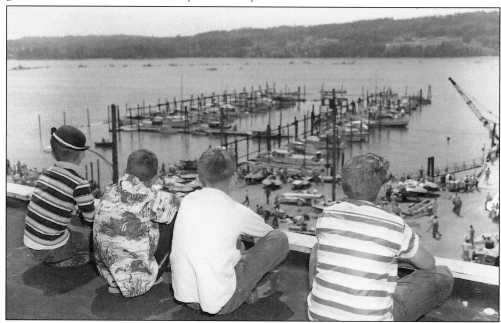

On July 4, 1959, a different kind of race was held on Liberty Bay. From left to right, Dennis, Terry, and Bruce Stenwick, along with Grant Alexander, watch hydroplane races from their perch on top of the Eliason building. In order to share celebrations with nearby communities, Poulsbo now holds its annual celebration on July 3, but footraces, food, fireworks, and fun remain the main attractions.

In 1939, the Poulsbo Eagles sponsored Poulsbo's first regulation soapbox derby. Here two soapbox cars are poised at the top of the ramp ready to make their run. The soapbox derby has recently been revived. Young racers now go down an inclined road near the Olympic College satellite campus. Today's cars may be more streamlined, but the determination of drivers remains the same.

In the 1960s, go-kart races gained the spotlight during the Independence Day weekend. Bales of hay placed down Front Street marked the race track and provided safe bumpers for karts and spectators alike. From the size of the drivers, it looks like youngsters were not the only go-kart enthusiasts in town. The go-kart races lasted about four years before Poulsbo turned its attention to other pursuits.

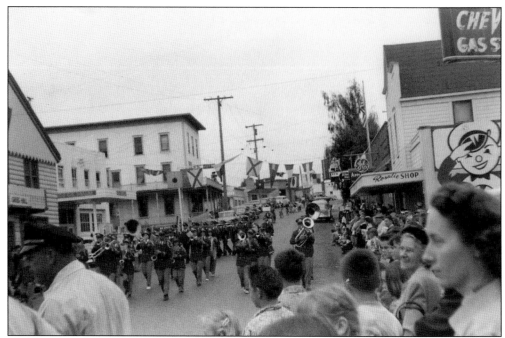

Poulsbo's population explosion during World War II turned the spotlight on children at the end of the war. To fund a growing summer recreation program, civic leaders introduced a new event, Play Days, a weekend of parades, street dances, contests, carnival rides, and concerts on Labor Day weekend. The North Kitsap High School Band leads the way down Front Street past the old Grandview Hotel in this 1950s photograph.

In the 1950s, nearly every kid had a bicycle, and decorating it with crepe paper streamers was a must for any parade. Here two young Poulsbo ladies use pedal power to travel the parade route. Can anyone hear the snapping of the playing card against the spokes as they go?

Fire trucks are always in Poulsbo parades. In the 1950s, Poulsbo's volunteer firemen built a clown truck for parades. Its wheels were offset so that it rolled awkwardly and required lifting around corners. Every chance they got, the firemen pulled and pushed the truck through a parade. Mostly unidentified, perhaps at their preference, known firemen are Leif Ness at the wheel, Martin Anderson (directly below Leif), and Charlie Olson (right).

Clowns, whether a professional chased by a whale, a semi-professional pushing a fire truck, or an amateur dressed by mom, are a welcome addition to Poulsbo parades. The identity of the professional is unknown, but the amateur preparing to head for the parade route is Poulsbo's Wayne Paulson. The kids of Poulsbo liked to dress up, it seems. In addition to Play Days, the town celebrated Halloween in a big way, with costume parades, games, and goodies for all in the 1950s. By the late 1950s, Play Days had run its course. The Halloween celebration held on until the early 1970s, but it did not take long for another celebration to take its place.

The new celebration was Viking Fest, a celebration of Norway's Constitution Day. Syttende Mai (the 17th of May) is a holiday in Norway and also in Poulsbo, where the town recalls its Scandinavian roots. The parade is the main event, with horses, of course. This team pulling an ornate carriage from an earlier time was an entry in a 1970s Viking Fest parade.

A horse of a different color is also welcome. The Paulson brothers, Val and Wayne, joined forces to prance their Cub Scout project through the parade. Viking Fest is open to all ages, and children as well as adults enjoy performing for the crowds. An annual entry in the Viking Fest parade is a band of ferocious Vikings, who terrorize the crowds lining the street, but that's much too scary to show here!

During Viking Fest, Norwegian *bunads* (costumes) are everywhere: on dancers and waitresses, on floats and walkers. This group of children from the Sons of Norway heritage club are preparing for the parade. Norwegian bunads are decorated to represent one's ancestral area in Norway. However, in a pinch, black pants or skirt, a white blouse, and a red vest and hat will do nicely. (Courtesy of Vic Heins Collection.)

As they did in this photograph from 1979, following the parade, crowds fill the waterfront park to spend the afternoon eating from food booths or dining at the Sons of Norway lodge, listening to musical entertainment in the park, or watching races on the bay. In more recent times, a carnival has set up in town. The weekend event ends with the Sons of Norway Syttende Mai ceremony.

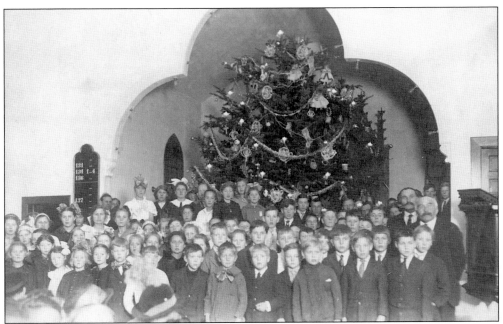

Christmas is a magical time in Poulsbo. In 1915, the town had a special reason to celebrate. On Christmas Eve, the city turned on electric lights for the first time. This photograph taken inside Fordefjord Lutheran Church (the earliest inside photograph) captured the Christmas Eve celebration and children's Christmas pageant. Electric light bulbs can be seen attached to the scalloped frame of the chancel area.

A different kind of magic was a tradition started by the volunteer fire department. Every Christmas season, the families associated with the department gathered cedar boughs from the woods and built long garlands to string across Front Street. Fastening boughs to the garland wire are, from left to right, Lorraine Haskin, Pauline Rindal, Frank Raab, and an unidentified helper. (Courtesy of Ness Collection.)

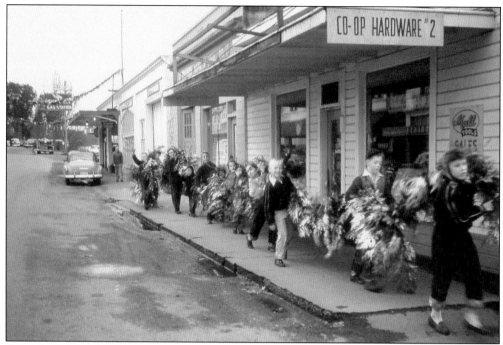

As each garland was finished, the children of the firemen carried it down the street to a truck used to lift the garlands into place. Leading the line with this garland is Judy Shields, whose father was a volunteer fireman. In later years, her younger brother, James, became a long-term fire chief for the city of Poulsbo. (Courtesy of Ness Collection.)

Christmas brings another Scandinavian celebration when the local Sons of Norway Lodge sponsors Julefest. With the arrival of the Lucia Bride aboard a Viking boat in the harbor, a Jule log is lit in the city's fire pit. Then, following Swedish tradition, Lucia passes out baked pastries to the hungry crowd to the accompaniment of Christmas carols. Here, Lucia Bride Felicia Korsmo treats the guests at the bonfire.

Poulsbo celebrates another cultural event on June 21. The summer solstice is Midsommarfest, perhaps the most colorful event in town. This day, folk dance groups from the Sons of Norway lead a promenade into Muriel Williams Waterfront Park, where the *maistang* (maypole) is raised. In this photograph from the 1980s, the pole is raised at Raab Park. In later years, the celebration was moved to the waterfront park.

After raising the pole, the afternoon is spent in folk dances led by Sons of Norway dance groups. While many of the dances are performances by colorful dance groups who know what they're doing, for the long line dances, spectators are invited to join in, making the celebration a truly community event. For those wanting to see many bunads, Midsommarfest is the place to be!

Cultural events abound in Poulsbo, and one of the tastiest is the Annual Lutefisk Dinner at First Lutheran Church (formerly Fordefjord Lutheran). Now over 100 years old, the annual dinner is held the third Saturday in October. Shown are three stalwart lutefisk cooks (from left to right), Cliff "Swede" Dahlstrom, Roger Serwold, and Maldor "Jake" Jacobson, inspecting the cod before it undergoes the transformation into lutefisk. Lutefisk connoisseurs abound in Poulsbo.

It is not necessary to be Norwegian to enjoy lutefisk, but it helps. Included in the all-you-can-eat meal are Swedish meatballs, boiled potatoes, apple salad, homemade *lefse*, and dessert. Watching Earl Hanson dive into his meal are Marlene Hattrick (left) and Donna Erickson. The church serves an average of 1,100 lutefisk dinners in one day. Some families are now in their fourth generation of working the lutefisk dinner.

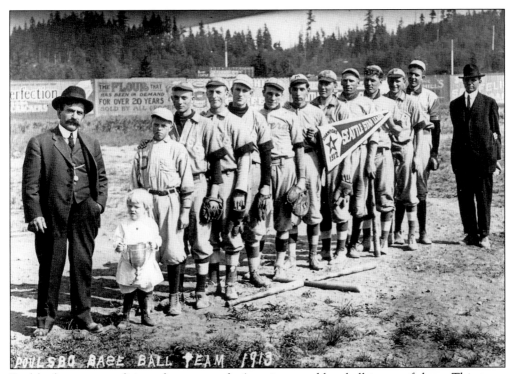

Poulsbo has some traditions that are purely American, and baseball is one of them. This town team won the baseball championship in a league sponsored by the *Seattle Star* newspaper in 1912. From left to right are manager Frank Martin, Henry Martin, Benny Mattson, Ted Mattson, Fred Fredericksen, Fuzzy Noftsger, Hardy Bergeson, Bill Harmon, Chris Twedt, Mandus Norman, Mel Borge, Fred Langeland, ? Hayse, and Godfrey Norman, umpire.

After the excitement of the championship, the town welcomed its heroes home with a scrumptious banquet in the Poulsbo Athletic Club (PAC). Flags flew, and the trophy was prominently displayed. This is one of the few photographs remaining of the inside of the PAC Hall. In 1917, the building was sold to the Sons of Norway and renamed Grieg Hall. It remains on Front Street as a warehouse.

In 1959, Poulsbo accomplished a Herculean feat, painting Front Street in one weekend. As part of a statewide challenge to prepare for the Seattle World's Fair in 1962, the town won the chance to receive a free color consultation and discounted paint from the Fuller Paint Company if it could organize and carry out the plan. These fellows were hanging around Grace Lutheran during Operation Paint-up. (Courtesy of Ness Collection.)

Another team of painters tackled a group of businesses on north Front Street. A team was assigned to each building, music flowed over Front Street to entertain the crews, and the Sons of Norway provided free lunch in the hall for everyone, a welcome break from the day's work. All ages, young and old, worked to accomplish the task, and there was no gender discrimination. (Courtesy of Ness Collection.)

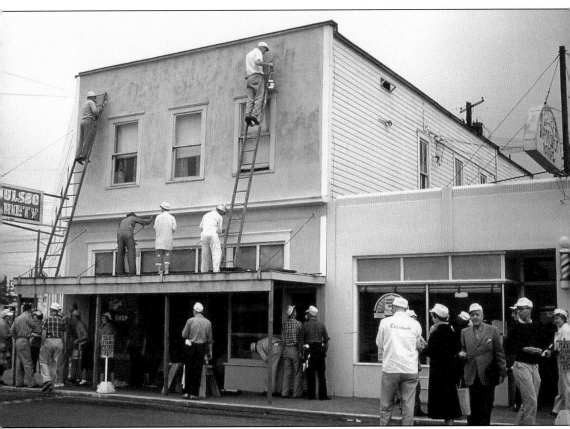

One of the paint teams tackles the front of Poulsbo's oldest storefront, the Hostmark building. The end result was stunning. After years of being a plain little burg on the bay, Poulsbo revamped its image and prepared to welcome tourists for Seattle's Century 21 World's Fair in 1962. As a result, Poulsbo was named a host city for the fair. (Courtesy of Ness Collection.)

Building on Operation Paint-up's success, Poulsbo adopted a Scandinavian theme. Two husband-and-wife artist teams who contributed to further decoration in the business district were Marge and Mel Schmuck and Annie and John Campbell. Marge (left) and Annie are shown here working on a Christmas window. Signs and trim on buildings carried Scandinavian touches that remain today, earning Poulsbo the nickname "Little Norway." (Courtesy of Campbell Collection.)

ABOUT THE POULSBO HISTORICAL SOCIETY

The Poulsbo Historical Society's motto, "Bringing the past to life," is also its mission. Founded in 1991 as a registered nonprofit corporation, it began gathering photographs, artifacts, and records of the century-old community. For 15 years it operated out of a cramped closet in city hall and the gracious gift of three storage units, in addition to a few private barns and basements.

In 2003, the Bight of Poulsbo, led by Bill Austin, raised funds and moved an original homestead cabin to Nelson Park, then began restoration of the old structure. It was a gift to the city. The Poulsbo Historical Society was granted the right to maintain the inside of the cabin for an exhibit of early home life in Poulsbo. The Martinson Cabin had a grand opening in 2006 and is open free of charge to the public on Saturdays year-round and by special appointment for small group events. It offers the society a place to display artifacts representing Poulsbo between 1883 and 1930.

When Poulsbo opened its new city hall in 2010, the Poulsbo Historical Society bought a portion of the building for a museum and office. The historical museum and small research library are open Wednesdays through Saturdays from 10 a.m. to 4 p.m. at 200 Moe Street in downtown Poulsbo. Exhibits feature all eras of Poulsbo history and are changed on a rotating schedule. There is always something new to find at the museum. The research library is small but active and welcomes queries about the history of Poulsbo and area families.

The active organization has been instrumental in publishing two books: *The Spirit of Poulsbo*, published in 2009, is a comprehensive look at Poulsbo's history from its beginning to 2008. Those who have whetted their appetite for Poulsbo history in this volume will be interested in perusing *The Spirit of Poulsbo* for a more in-depth presentation. The second publication is this one, a pictorial look at Poulsbo and its surrounding neighborhoods published by Arcadia Publishing.

Membership meetings are held the second Tuesday of each month with an evening presentation once a quarter. Interesting speakers and history-related activities are part of every meeting, and visitors are always welcome.

The Poulsbo Historical Society may be contacted via e-mail at info@poulsbohistory.org, on the Web at www.poulsbohistory.org, by snail mail at PO Box 844, Poulsbo, WA, 98370, or by phone at 360-440-7354.

DISCOVER THOUSANDS OF LOCAL HISTORY BOOKS FEATURING MILLIONS OF VINTAGE IMAGES

Arcadia Publishing, the leading local history publisher in the United States, is committed to making history accessible and meaningful through publishing books that celebrate and preserve the heritage of America's people and places.

Find more books like this at
www.arcadiapublishing.com

Search for your hometown history, your old stomping grounds, and even your favorite sports team.